Matisse
and Fauvism

Diana Vowles

DAWN
OF
MODERN
ART

Matisse
and Fauvism

Contents

Published in the USA 1994 by JG Press
Distributed by World Publications, Inc
JG Press is a trademark of World Publications, Inc
455 Somerset Avenue, North Dighton, MA 02764
ISBN 0-9640034-4-9
North American Rights only

The Dawn of Modern Art
is an imprint of Cromwell Editions Limited and Ninic & Ninic
©*Text copyright by*
Ninic & Ninic and Cromwell Editions Limited

Designed by Paul McTurk BA MCSD
Printed by Tiskarna Ljudske Pravice, Slovenia

Introduction Fauvism was the first of the major revolutionary movements to occur in European art in the 20th century and although it lasted less than three years after it gained its name in 1905 its liberating influence upon artists searching for alternatives to the traditions of the previous century was immeasurable.

The Fauvists' rejection of perspective and conventional spatial relationships in favor of brilliant non-naturalistic colors sent shock waves through the art world that reverberated long after the movement was dead and its artists had moved on to other styles.

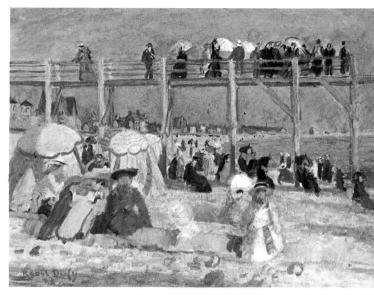

Dufy: *Beach at St Adresse,* 1904

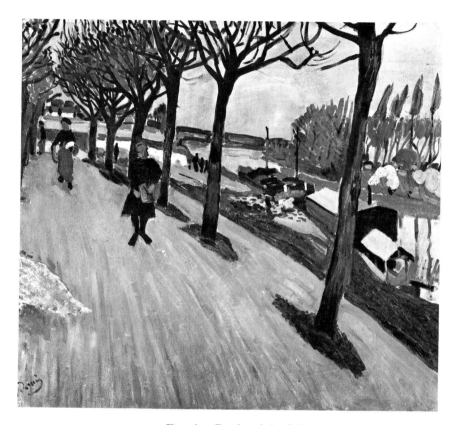

Derain: *Banks of the Seine,* 1904

Unlike most movements in art, Fauvism was not based upon a doctrine created by a group of painters with a shared aim. It was instead a meeting point that occurred when a number of painters, each seeking a personal style that broke with the past, arrived at the same solution for creating a modern art for a new century. Fauvism was characterised mainly by its pure, intense, even shocking colors, and apart from this its artists had little or nothing in common; after the movement had reached its peak each painter continued on his own path of artistic development and their styles were never to coincide again.

No new art movement can begin from a vacuum and Fauvism was not a giant leap of

Friez: *La Ciotat,* 1905

the artistic imagination from the traditionalism that dominated 19th-century French art. At the end of the century the Impressionists and Post-Impressionists, though still regarded with derision by those few members of the general public who had even heard of them, were gaining a foothold in the art world and the young artists, who were to become known as the Fauvists, were experimenting with principles laid down by Van Gogh, Seurat, Cezanne and Gauguin.

3

The intense, vivid colors of Fauvism began to appear in the closing years of the 19th century, most notably in the paintings of *Henri Matisse*. The movement began to coalesce in the first few years of the 20th century as a small group of artists expressed their reaction to their subjects by applying pure color direct to the canvas to give a violent, explosive effect. They went on painting trips together and began to exhibit as a group at the Salon des Independents, an annual exhibition at which any artist who could pay the fee could show his or her work.

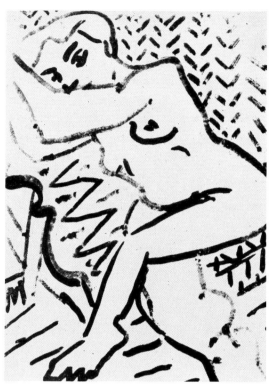

Matisse: Seated *Woman*, 1906

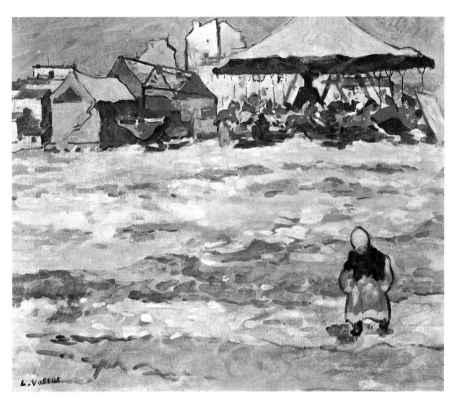

Valtat: *The Merry-Go-Round*, 1895-1896

It was at the Salon d'Automne of 1905 that Fauvism both reached its peak and gained its name; art critic Louis Vauxcelles, pointing to a work by the 14th-century Florentine sculptor Donatello, exclaimed, 'Donatello au milieu des fauves!' (Donatello among the wild beasts).

A number of artists were loosely associated with Fauvism, but the main figures were Braque, Camoin, Derain, Dufy, Friesz, Manguin, Marquet, Matisse, Puy, Valtat, Van Dongen and Vlaminck. Some reached their own artistic peak with Fauvism, while others went on to make a major contribution to modern art with their subsequent work. It was left to Matisse to pursue the principles he had initiated, retaining to the end his adherence to the use of brilliant color that was the basis of Fauvism.

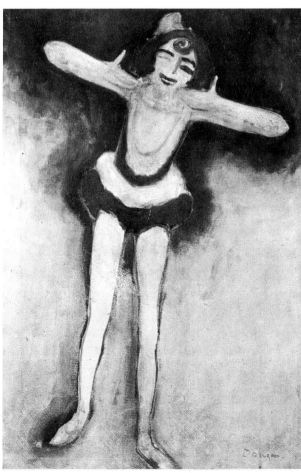

Van Dongen: *One-eyed Dancer Bowing*, 1905-1906

4

Braque Georges Braque was a towering figure in 20th century French art for he was, with Picasso, the joint creator of Cubism. His father and uncle were both amateur painters and admirers of Impressionism, with the result that his youthful work was much influenced by that movement. Although he had attended art classes in Le Havre with Friesz and Dufy, he was a late-comer to Fauvism; it was not until the Salon d'Automne exhibition of 1905 that he became attracted to it, and his Fauve paintings, which total about 40, were all produced between 1906 and the spring of 1907. He painted the first of these during a trip to Antwerp with Friesz. He exhibited with the Fauves in 1906 and 1907, but after seeing the Cézanne Memorial Exhibition at the Salon d'Automne in 1907 he began to paint in a geometrically analytical style. It was in the same year that he first met Picasso and the two worked closely together until Braque was called to the trenches of World War I in 1914. After he was discharged with serious wounds in 1916 his style began to diverge from Picasso's with graceful curves replacing angularity.

He illustrated books, designed stage sets and costumes and in 1913 invented *papier colle*, in which pieces of decorative paper are incorporated into a painting or, glued to a ground such as canvas, even constitute a picture in themselves.

In 1961 he was paid the honor of being the first living artist to have his work exhibited in the Louvre. He died in Paris in 1963, aged 81.

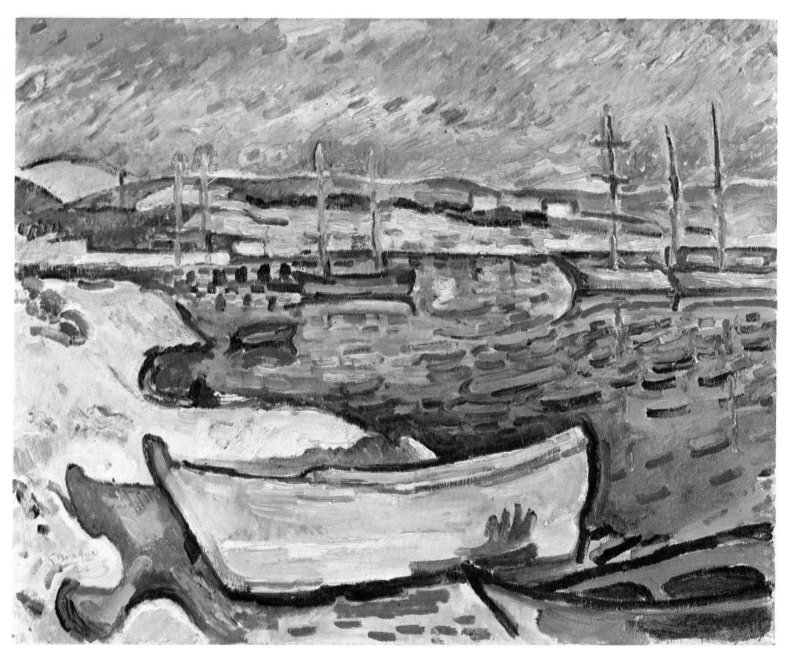

Georges Braque: *The Yellow Seacoast or Boats in the Bay,* 1906

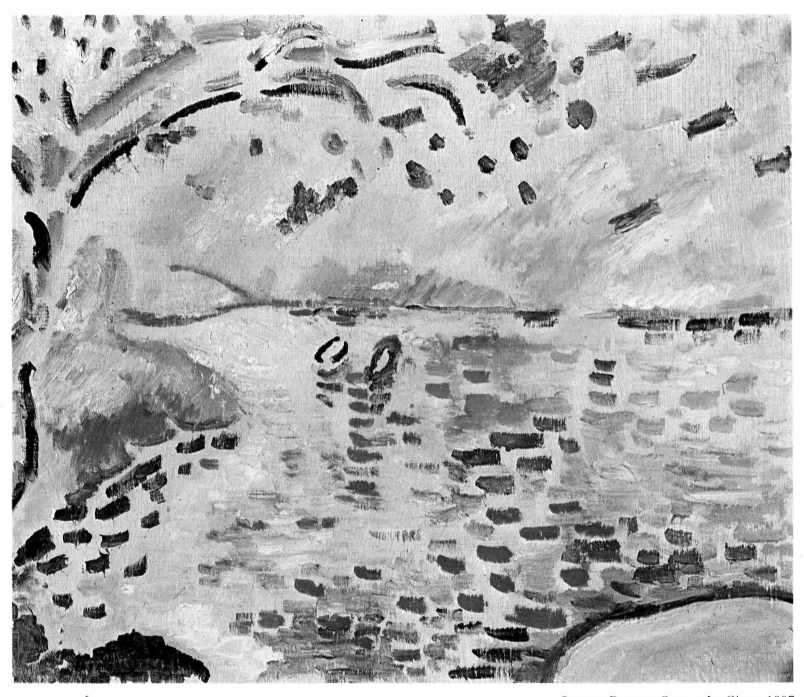

Georges Braque: *Cove at La Ciotat*, 1907

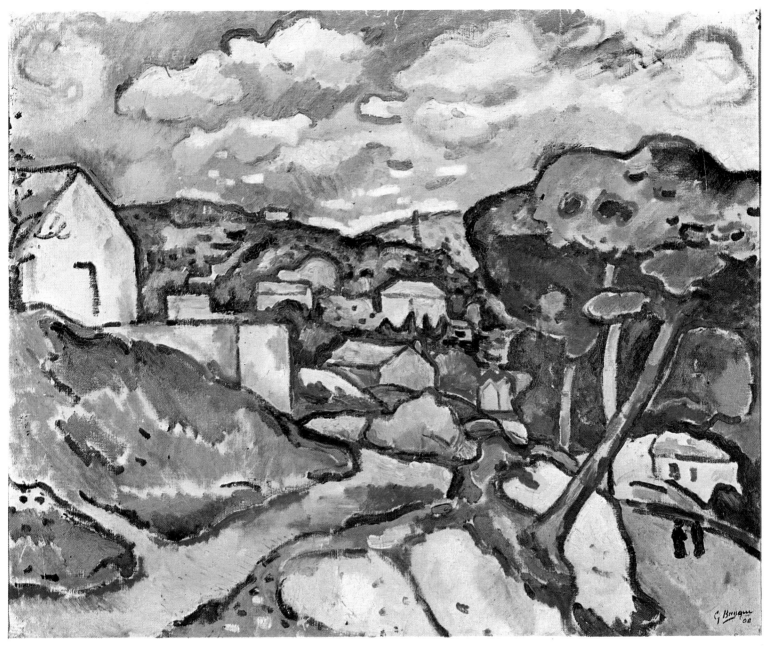

Georges Braque: *View of L'Estaque*, 1906

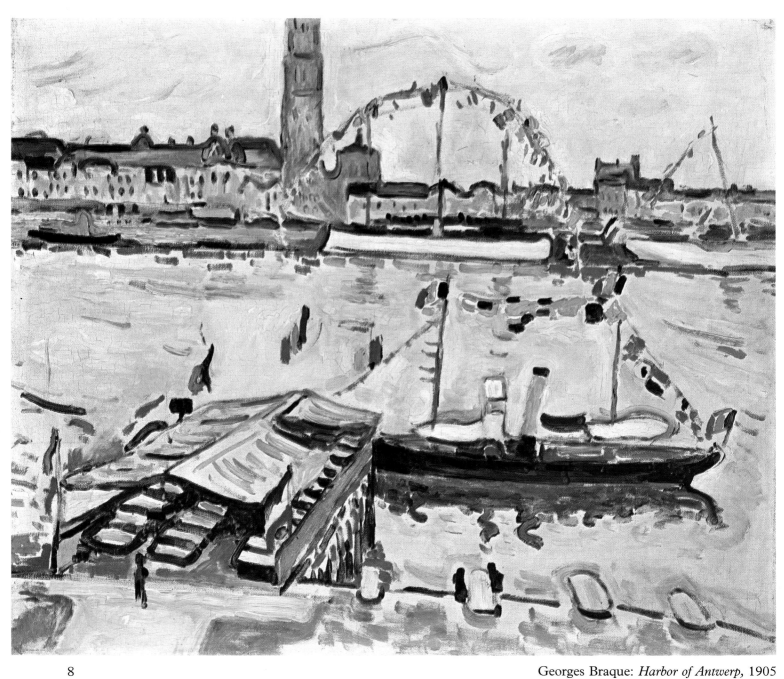

Georges Braque: *Harbor of Antwerp,* 1905

Charles Camoin Camoin was born in Marseilles in 1879 and attended art school there before moving to Paris, where he enrolled at the atelier of the Symbolist painter Gustave Moreau, an inspired teacher. Here he first encountered Matisse and Manguin. During a period of military service at Aix-en-Provence he met Cézanne, who had a strong influence on his art. He first exhibited at the Salon des Indépendents in 1903, in company with Manguin, Matisse and others of the group who were to become known as the Fauvists.

His paintings were of a less violent nature than that of the rest of the group, and he favored luminous effects and gentle subjects such as flowers and landscape. Like the other Fauvists, he subsequently moved on to a different style of painting.

He died in 1965.

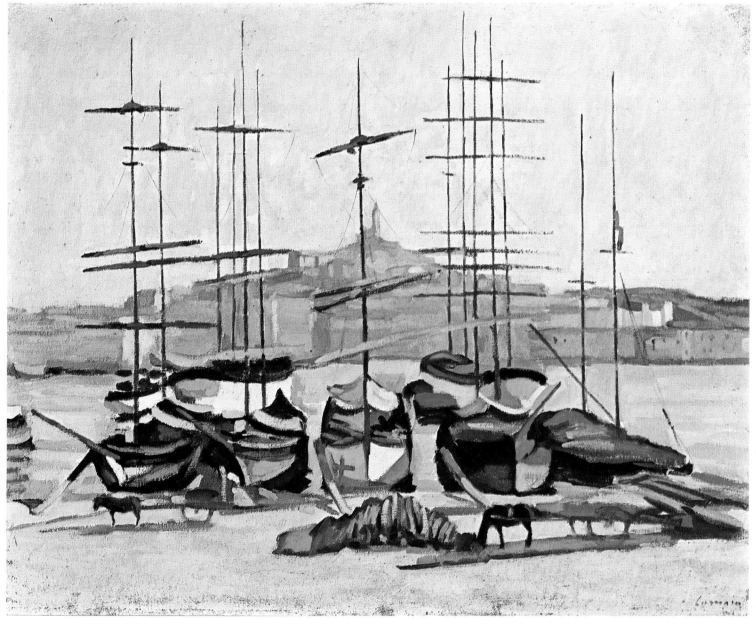

Charles Camoin: *The Port of Marseilles,* 1904,

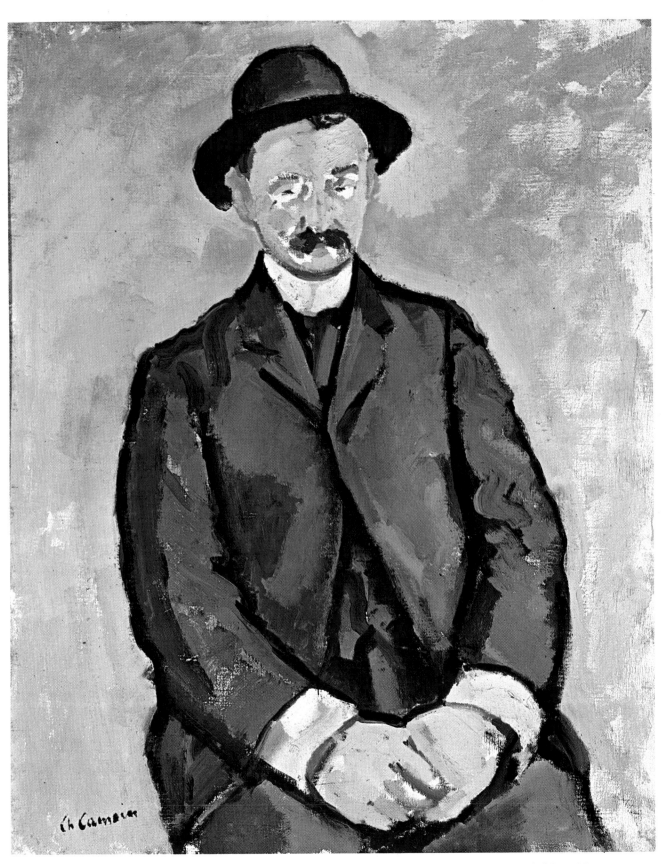

Charles Camoin: *Portrait of Albert Marquet*, 1904

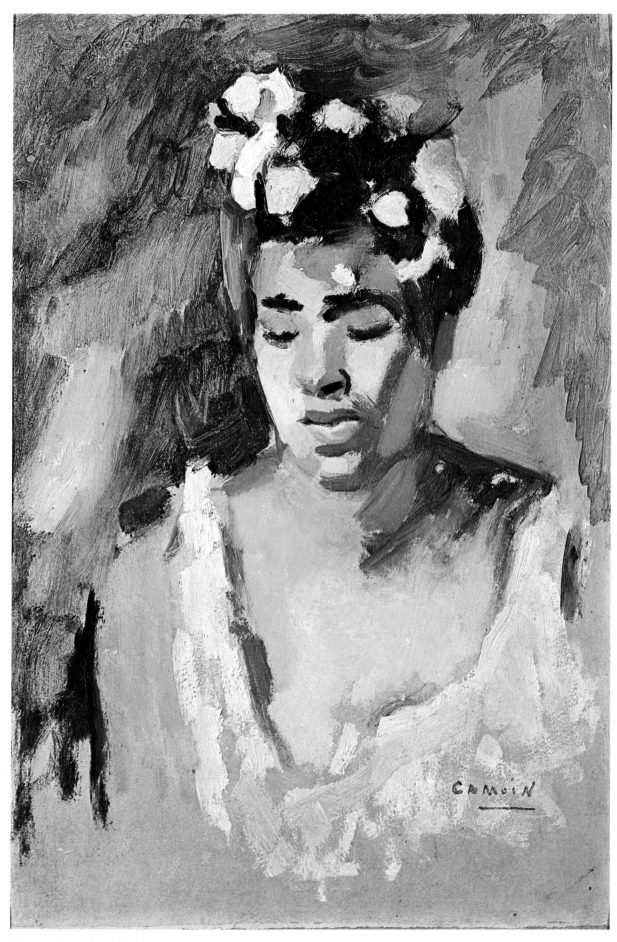

Charles Camoin: *The Negress*

André Derain Although he was one of the leading members of the Fauves, Derain later reacted against non-representational art and became one of France's staunchest adherents of realism. Born in Chatou in 1880, he faced parental opposition to the idea of his becoming an artist but nevertheless managed to forge his way to the Carriere Academy in Paris, where he met Matisse. In 1901 he became friends with Vlaminck, and illustrated two of the latter's novels; more importantly, he introduced Vlaminck to Matisse at a Van Gogh exhibition, completing the trio that was to form the nucleus of Fauvism. Derain and Matisse spent the summer of 1905 painting at Collioure, on the Mediterranean coast of France just north of the border with Spain, and it was during this period that Derain's art matured as he expressed his response to the landscape in brilliant colors and broken brushstrokes.

His Fauvist period came to an end in 1908, when he spent some time with Picasso in Avignon and moved towards an interpretation of form that was influenced by Cézanne's work. In spite of his continued association with Picasso he never fully embraced the concept of Cubism and after a visit to Italy he reverted to a traditional style based on that of the Old Masters. He also produced many book illustrations and designed for the stage.

He died in Chambourcy at the age of 74.

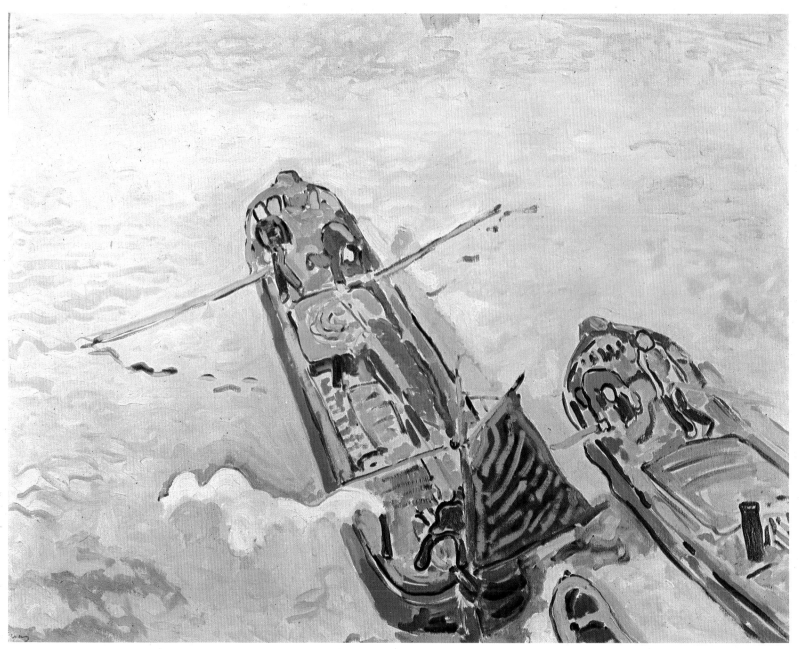

André Derain: *Barges*, 1904

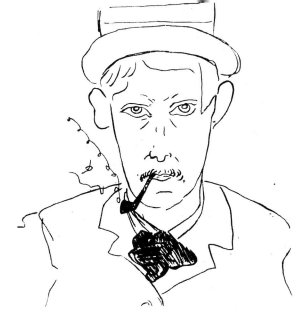

Vlaminck: *Portrait of André Derain*

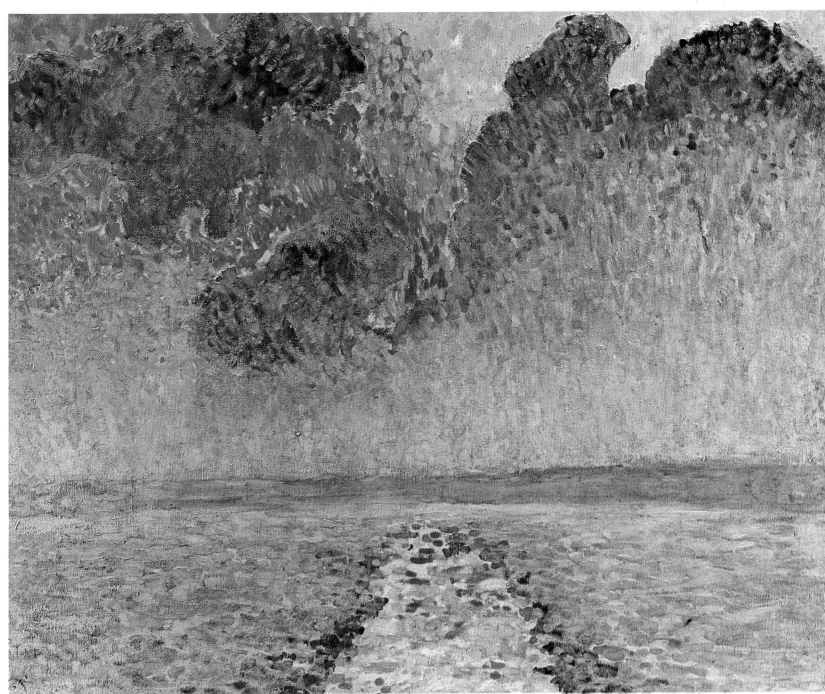

André Derain: *Reflections on the Water*, 1904

13

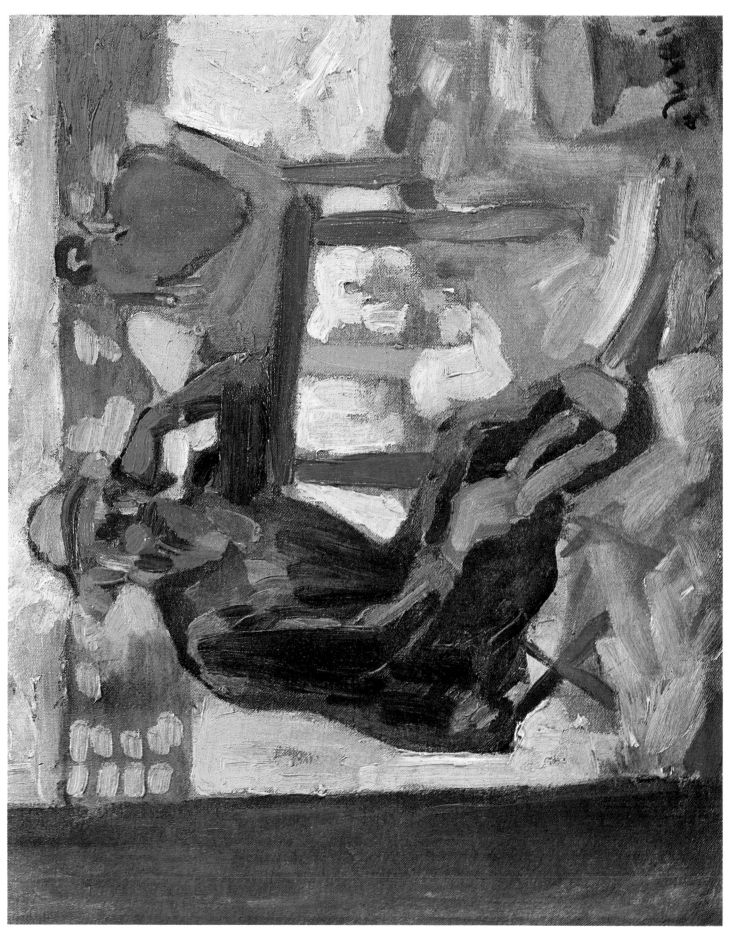

14 André Derain: *Portrait of Henri Matisse*, 1905

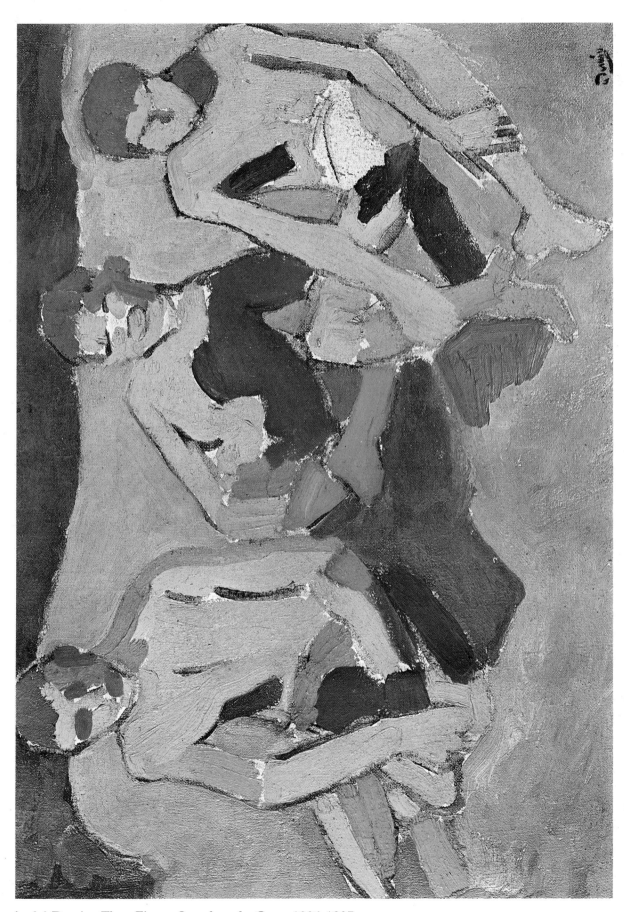

André Derain: *Three Figures Seated on the Grass*, 1906-1907

15

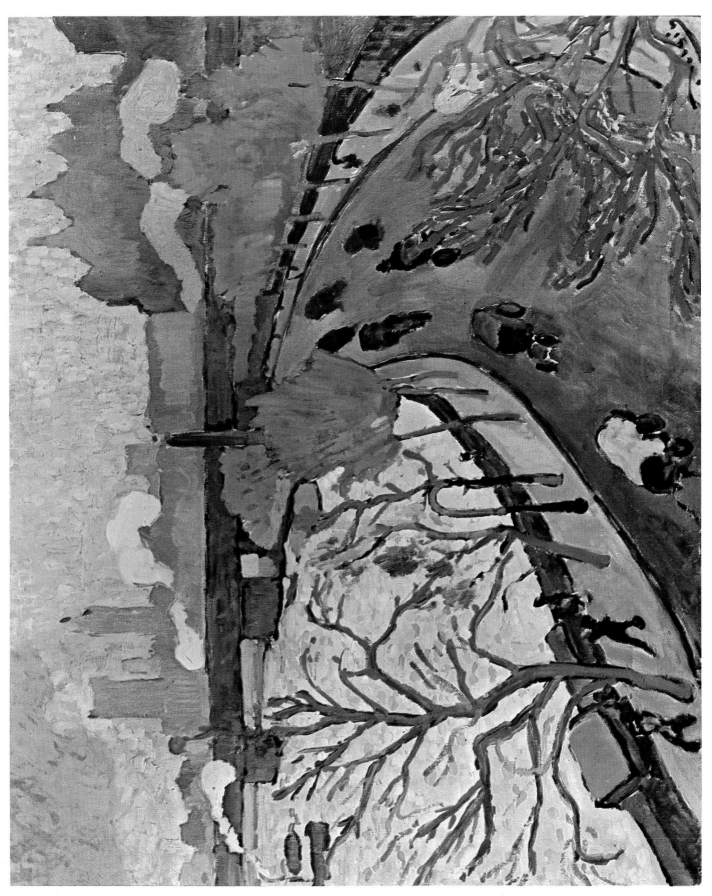

André Derain: *Westminster Bridge*, 1906

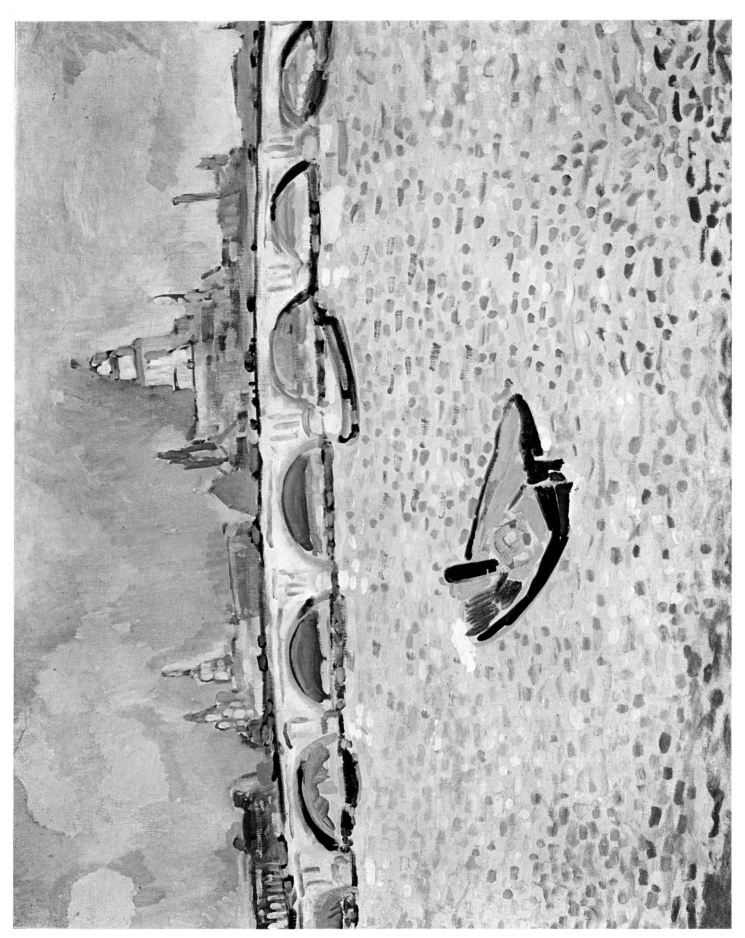

André Derain: *Bridge on the Thames*, 1906

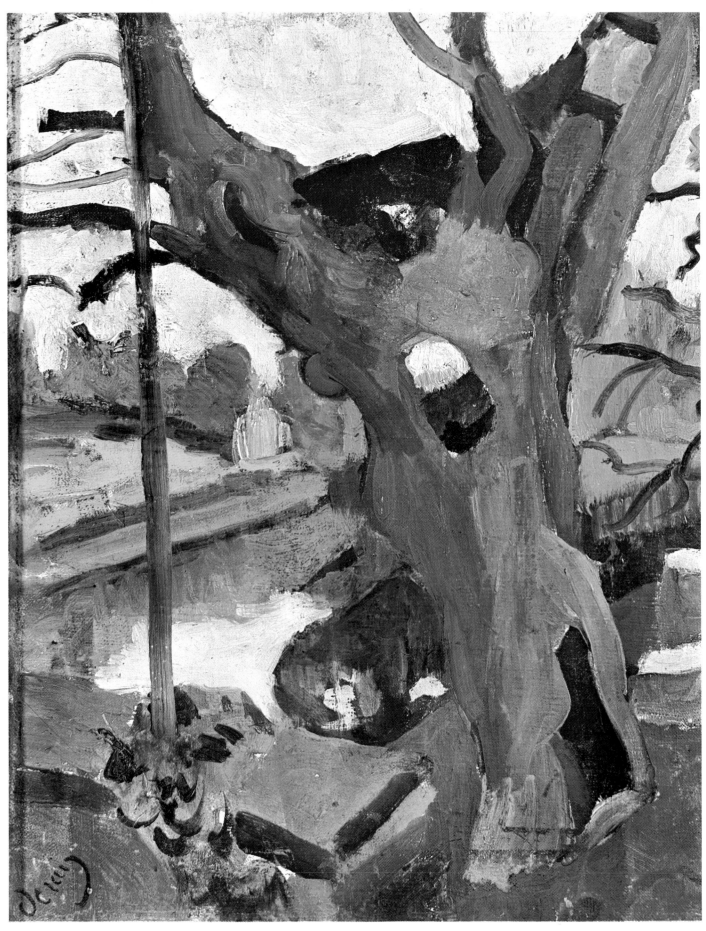

André Derain: *The Old Tree*, 1904-05

Raoul Dufy Born in Le Havre in 1877, he first took tuition in art at evening classes, where he met Othon Friesz and Georges Braque. In 1899 he gained a scholarship to the prestigious Ecole des Beaux-Arts in Paris and in 1901 exhibited at the Salon des Artistes Français. He established contact with the Fauves in 1904 and was greatly influenced by Matisse, exhibiting with them at the famous Salon d'Automne in 1905. Dufy spent some time painting with Marquet at Fecamp, Honfleur and Le Havre before moving on to Trouville and Cannes in the south of France, when the bright light of the Mediterranean was reflected in his use of color. In 1908 he came under the influence of Braque's experiments with Cubism and his canvases became more structured and sombre.

In the 1920s he returned to the Mediterranean to live, and developed his own very personal style of calligraphic drawing on brilliant background washes, depicting scenes of sailing boats and racecourses that helped to popularise modern art. Over the course of his long life Dufy also designed textiles, theatre scenery and ceramics, illustrated books and executed wood carvings.

He died in Provence in 1953.

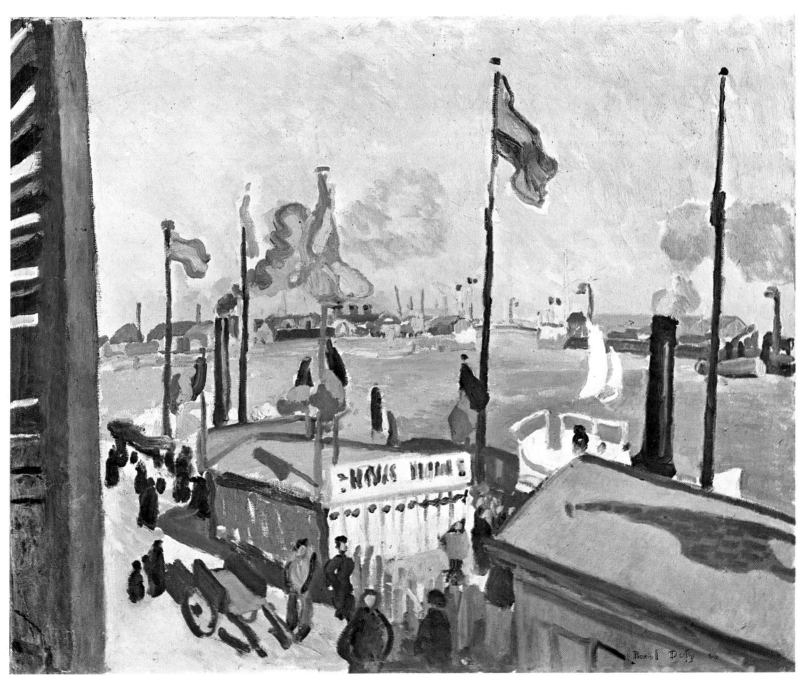

Raoul Dufy: *Port of Le Harve*, 1906

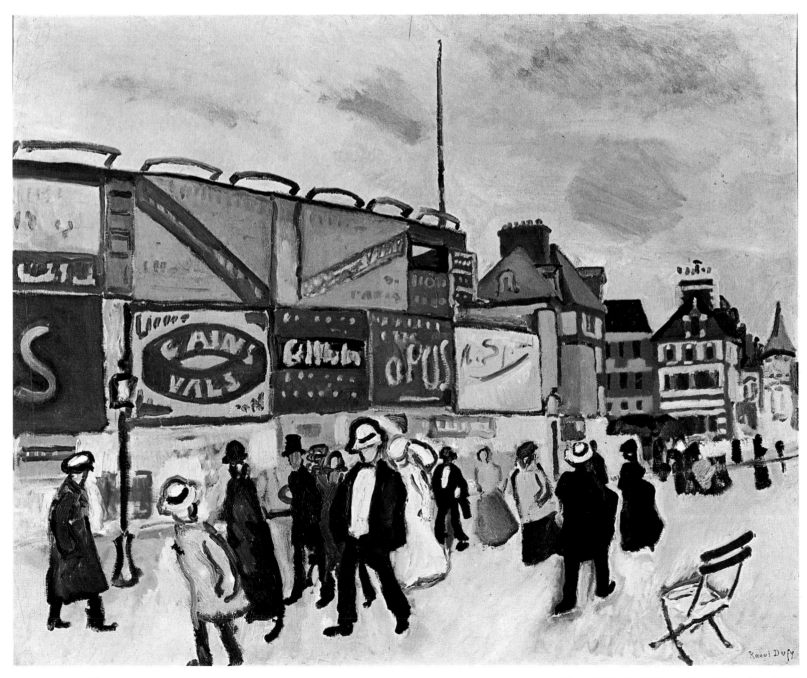

Raoul Dufy: *Billboards at Trouville*, 1906

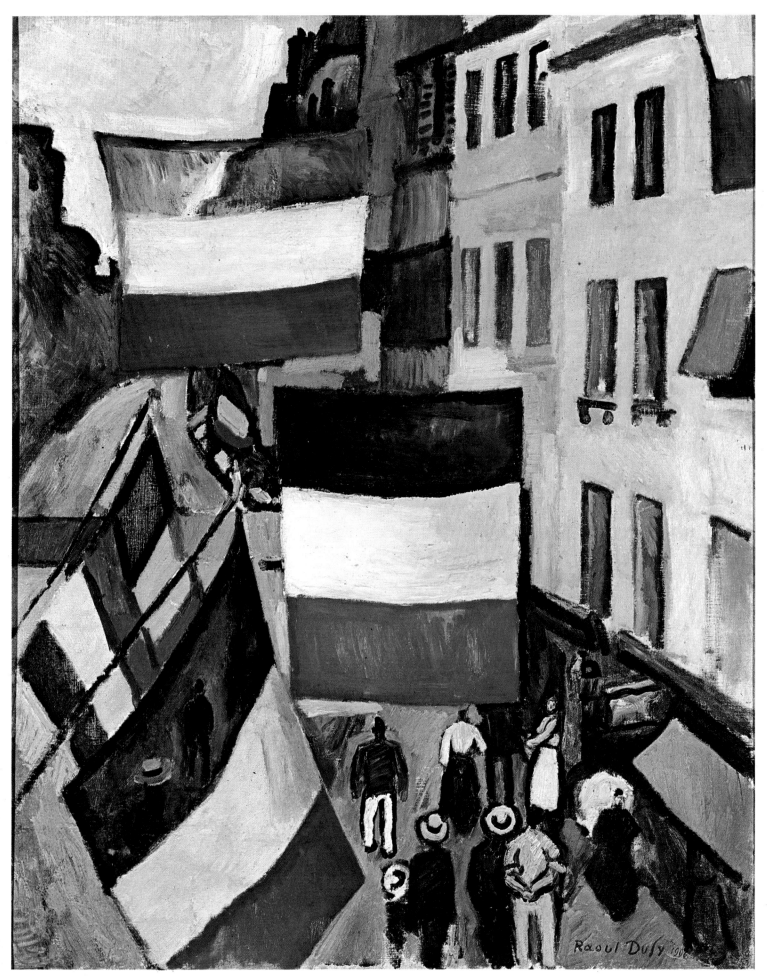

Raoul Dufy: *Street Decked with Flags*, 1906

21

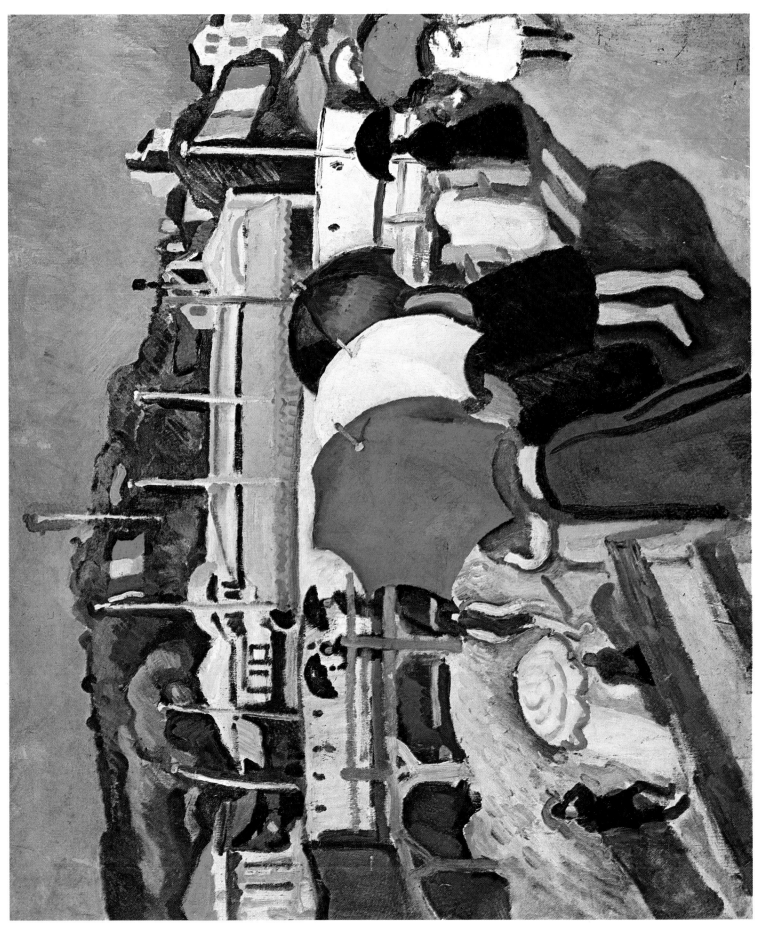

22

Raoul Dufy: *Parasols*, 1906

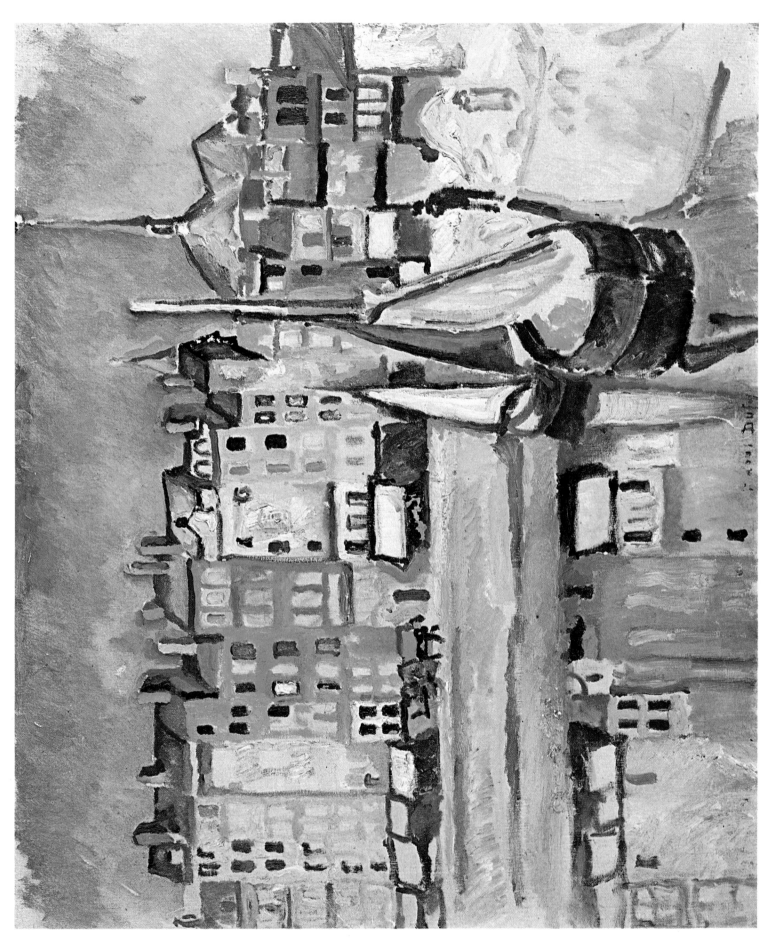

Raoul Dufy: *Old Houses on the Harbor of Honfleur,* 1906 23

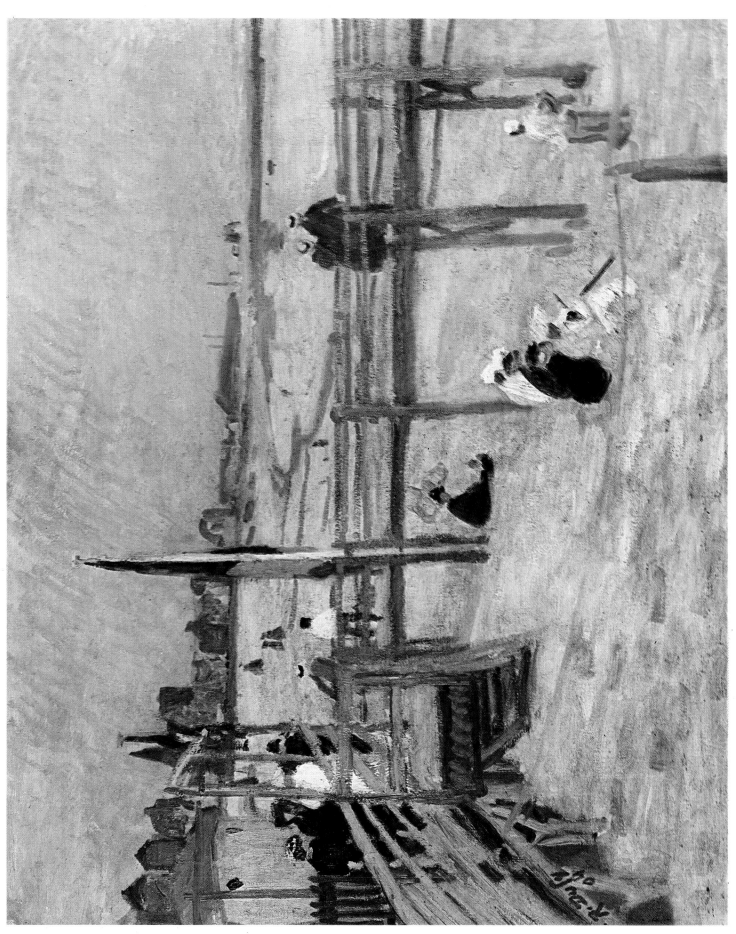

24　　　　　　　　　　　　　　　　　　　　　　　Raoul Dufy: *On the Beach at St Adresse*, 1904

Othon Friesz

Friesz was born in 1879 in Le Havre, on the north coast of France, and it was perhaps his childhood surroundings that engendered the love of the sea that was manifested in his paintings. When he moved to Paris in 1898 his art was influenced by Impressionism, but he consciously sought to develop a style that would take him in a new direction and after he met Matisse he became one of the most enthusiastic painters in the Fauve style. In 1906 he travelled with Braque to Antwerp, where both were inspired by the busy life of the port. Their styles at this time were very similar, though Friesz's paintings had a less ordered composition than Braque's. In 1908 Friesz turned away from Fauvism and reverted to a more traditional style. A highly successful painter, he taught at the Scandinavian Academy and became the principal of a school of fine arts. However, he was never again to be in the forefront of innovative art. He died in Paris in 1949.

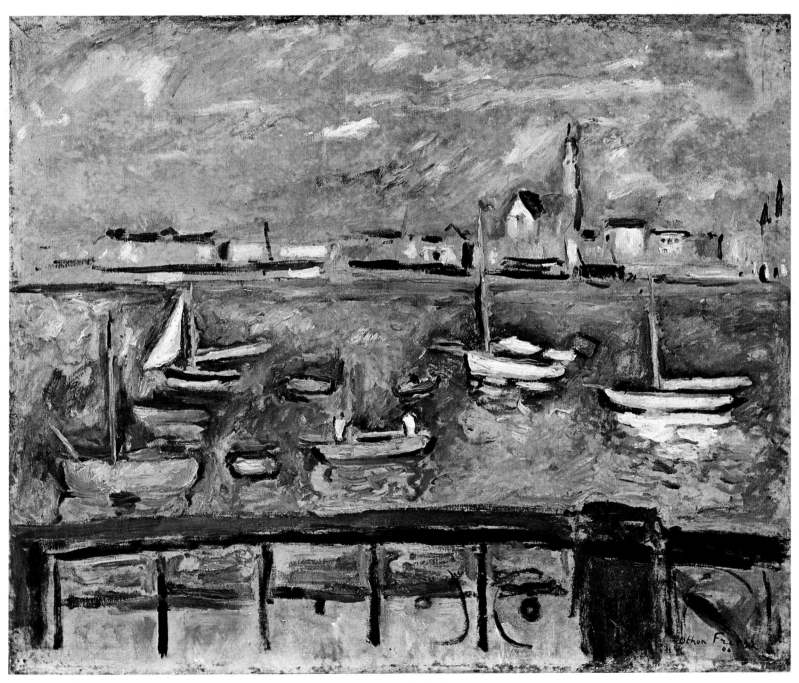

Othon Friesz: *Harbor of Antwerp*, 1906

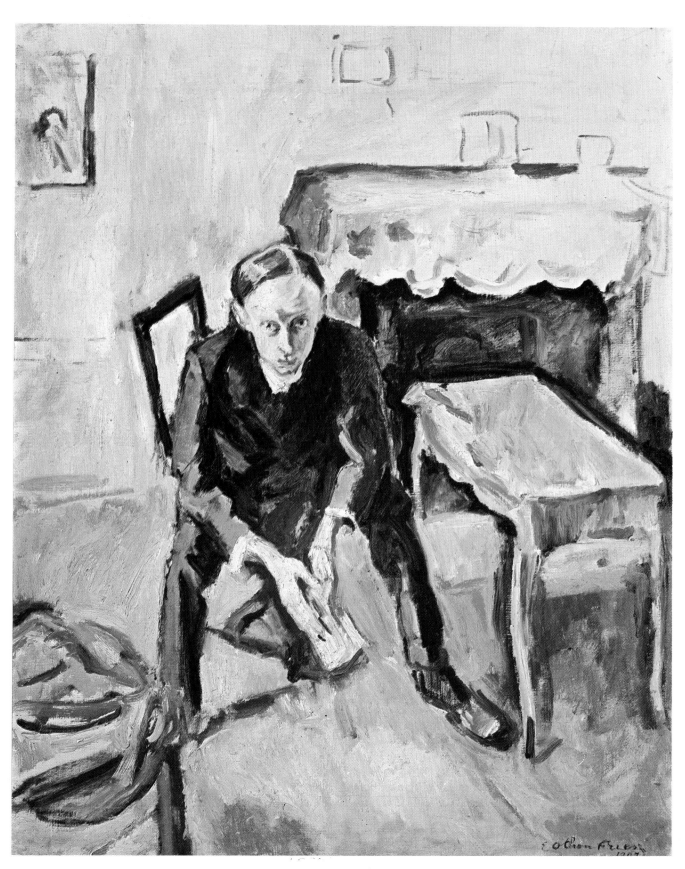

26 Othon Friesz: *Portrait of the Poet Fernand Fleuret*,1907

Albert Marquet

Marquet was born in Bordeaux in 1875 and showed such an early predilection for art that his family moved to Paris so that he could receive proper training. In 1890 he met Matisse and formed a friendship that was to last for the rest of his life. The pair studied together under Gustave Moreau, during which time they embarked on ambitious experiments with pure and brilliant colors.

After the famous Salon d'Automne exhibition of 1905, Marquet turned to a more naturalistic style of landscape painting. From the mid-1920s he largely used watercolor as his medium and favored the bridges and quays of Paris as his subjects - a quieter style of art that accorded better with his rather shy personality than the violence of Fauvism. He died in Paris in 1947.

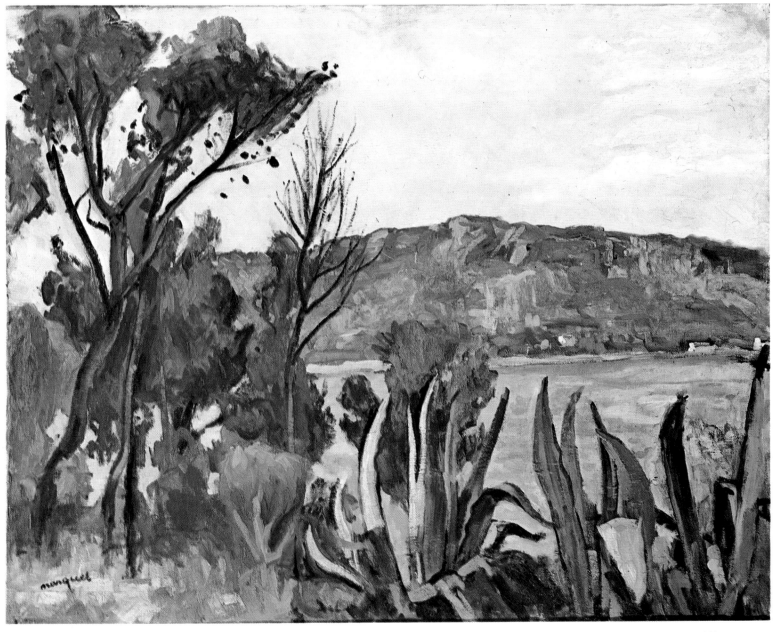

Albert Marquet: *View of Agay,* 1905

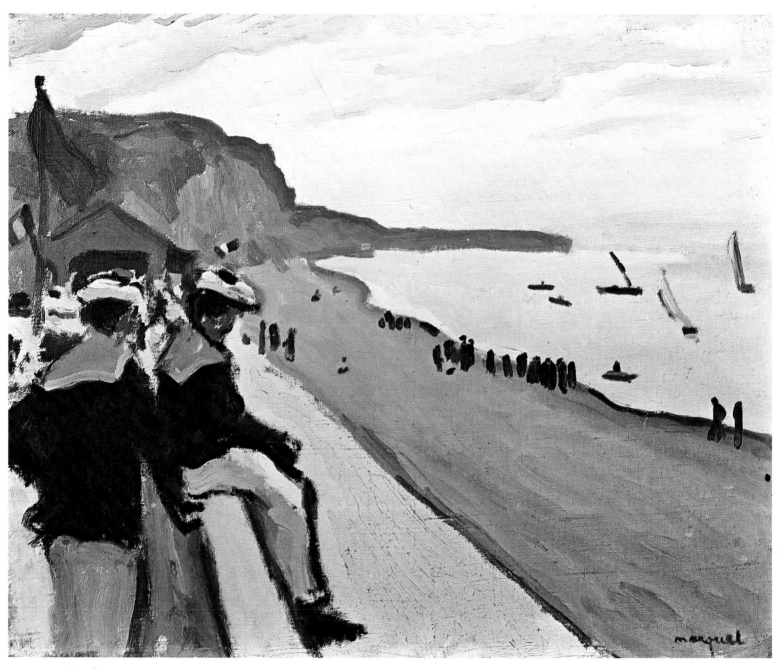

Albert Marquet: *The Beach at Fécamp,* 1906

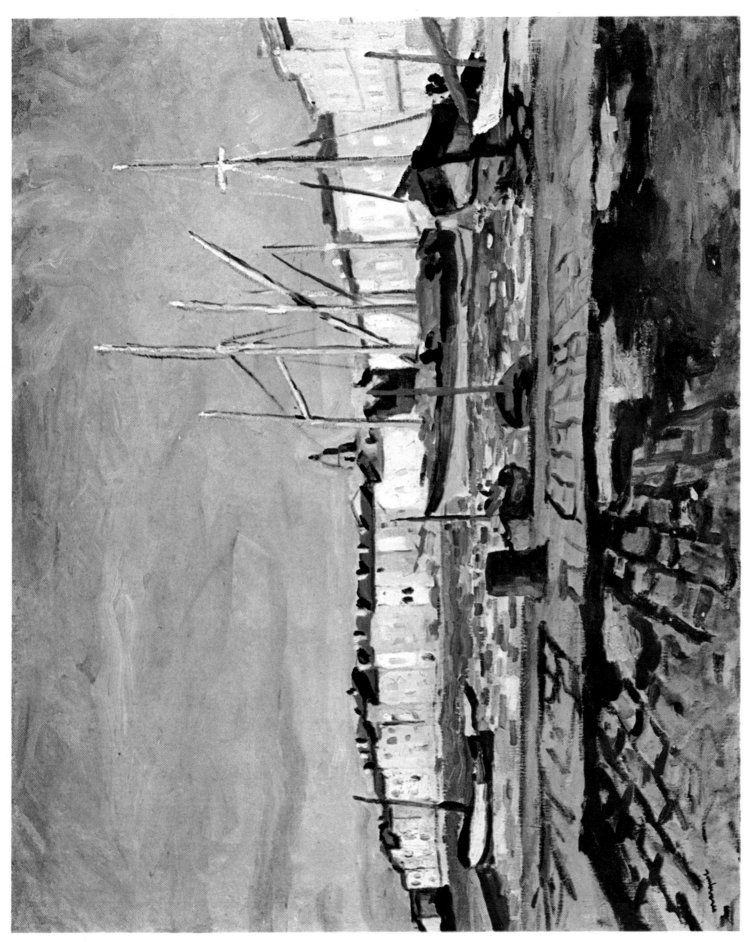

Albert Marquet: *The Port of Saint Tropez*, 1905

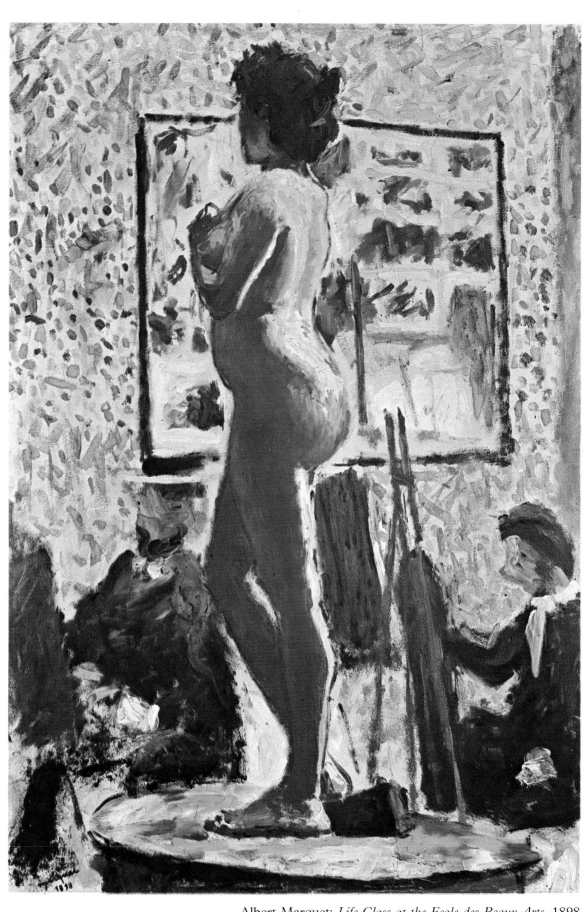

Albert Marquet: *Life Class at the Ecole des Beaux-Arts*, 1898

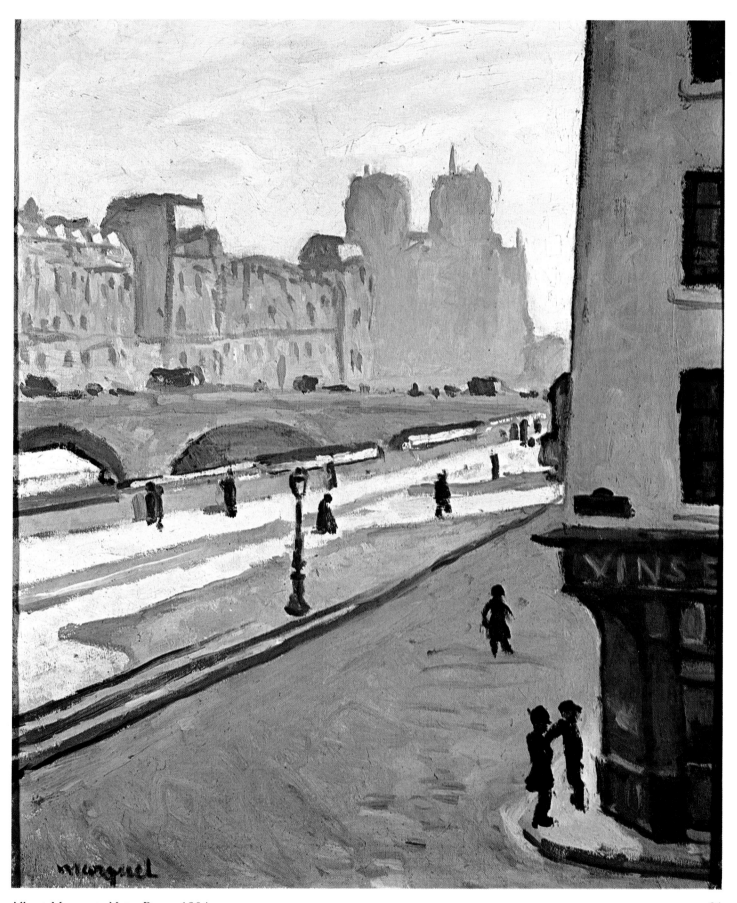

Albert Marquet: *Notre Dame*, 1904

31

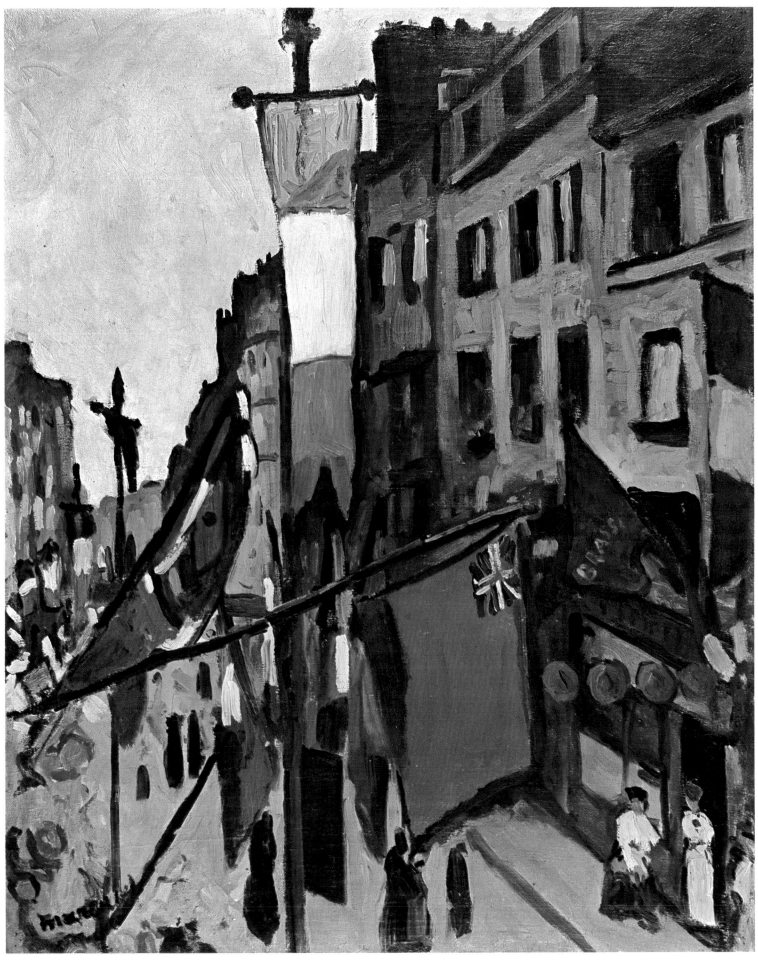

Albert Marquet: *Fourteenth of July*, 1906

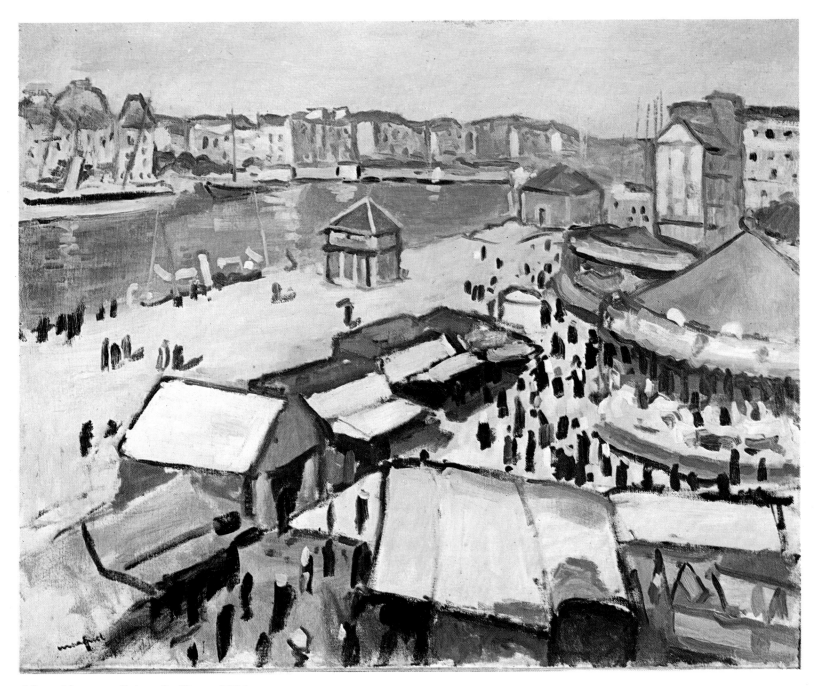

Albert Marquet: *Fair at Le Havre,* 1906

Henri Manguin While Manguin is regarded today as one of the more minor artists of the Fauvist movement, he was nevertheless one of the more innovative members of the group and the first to use pure colors. Born in Paris in 1874, he joined the Moreau atelier in 1895, where he met Matisse, Marquet, Puy and Camoin. He exhibited in 1902 at the Salon des Indépendents and in 1904 at the Salon d'Automne. After a brief sojourn in Switzerland during World War I, he divided his life between Paris and St Tropez, painting mainly landscapes and figures. He died in 1949.

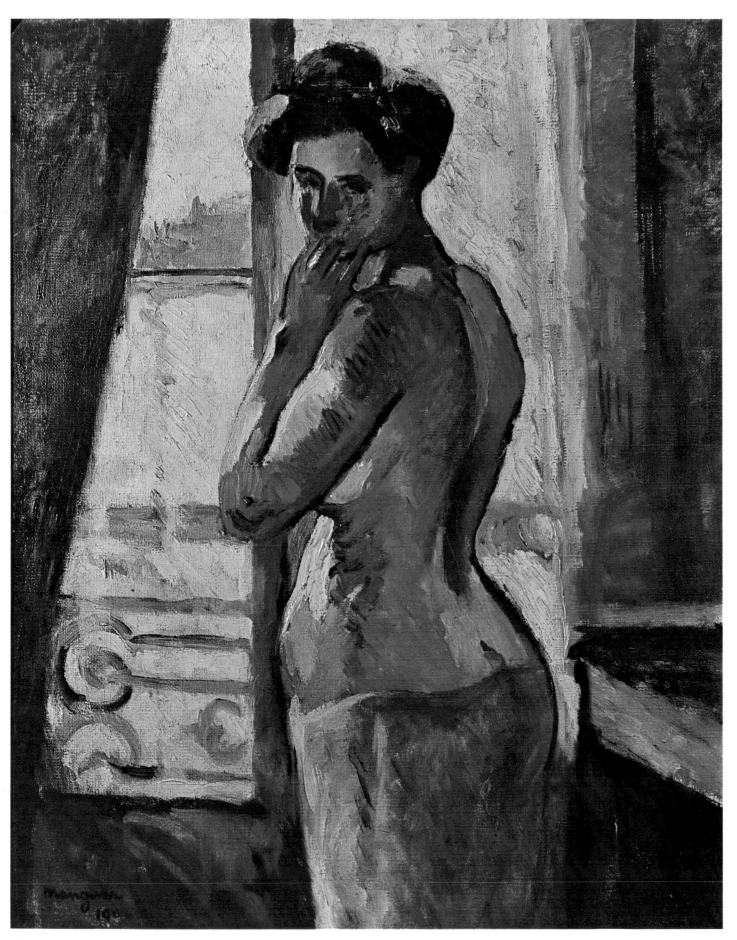

Henri Manguin: *Woman at the Window*, 1904

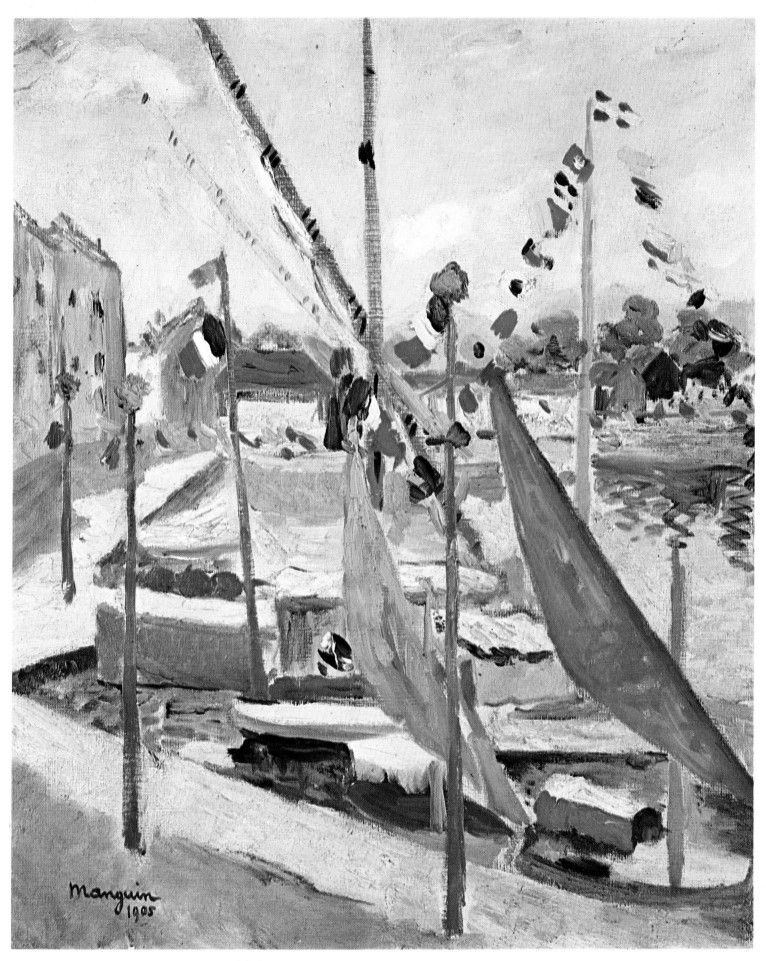

Henri Manguin: *July Fourteenth: Port of Saint Tropez,* 1905

Henri Matisse

Matisse was born in Le Cateau, northern France, on the last day of 1869. On leaving school he embarked on the study of law and only became seriously interested in art when his mother gave him a box of paints to keep him amused while he was recovering from severe appendicitis at the age of 20. The next year he abandoned law and went to Paris determined to become a professional artist. His early training was not particularly satisfactory and it was not until he joined Moreau's atelier at the École des Beaux-Arts in 1892 that his great gifts were nurtured. In the late 1890s he saw a series of Impressionist masterpieces that had just been donated to the French nation and his use of color became lighter and more intense. In 1897 he took his first stride towards an individual and liberated style and caused shock waves in the art world with his painting *The Dinner Table*, a classical composition that was rendered in deep red and green. From there he moved on to an interest in Pointillism, where dots of pure color are used in such a way that when the canvas is viewed from a distance they appear to react together optically, creating more luminous and vibrant effects than if the pigments had been mixed together before application to the canvas. Although he was by no means affluent, he bought canvases by Cezanne and Gauguin and a bust by Auguste Rodin, whom he had met during a holiday at Belle Ile in the Bay of Biscay.

It was during his visits to Belle Ile in 1896 and 1897 that Matisse's canvases first began to

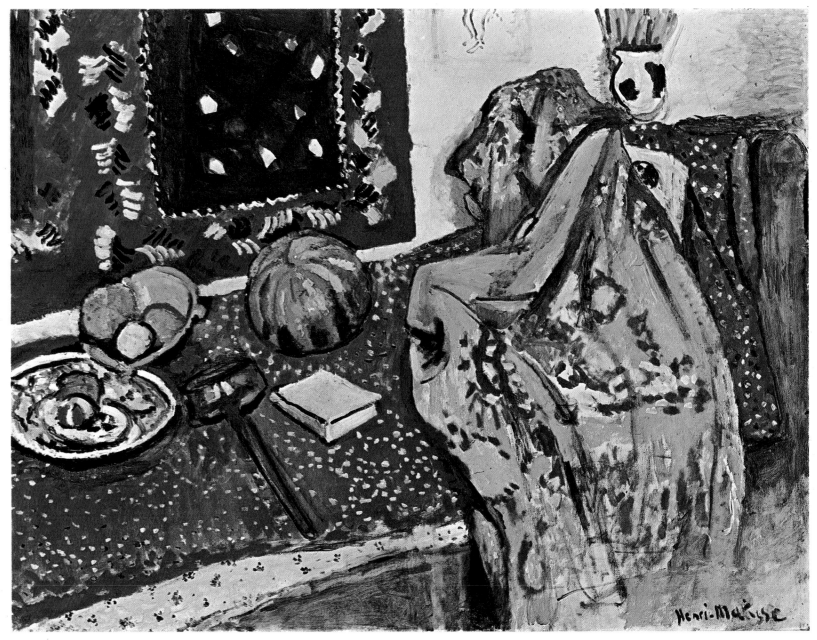

36

Henri Matisse: *Still Life with Red Carpet*, 1906

display the vivid colors that characterise his work. However, the biggest influence that next came into play was the intense Mediterranean light that he encountered on a trip to Corsica in 1898.

Back in Paris in 1899, Matisse began to experiment with Neo-Impressionism. In 1901 he exhibited for the first time at the Salon des Indépendents, but the early years of the 20th century were hard for him: he succumbed to a prolonged bout of bronchitis that left him severely debilitated, his finances were frequently strained and his first one-man show in 1904 was a failure. However, 1905 was a turning point. In Collioure with André Derain, he broke free of what he termed the 'tyranny' of Pointillism and his brushstrokes changed from small dabs to swirls of exuberant colors - blue, orange, violet, yellow, red and green in daring juxtaposition with each other. *Open Window*, painted at Collioure, and *Woman with the Hat*, a portrait of his wife done in Paris in September, were exhibited at the Salon d'Automne where the Fauvists gained their name and Matisse rapidly came to be considered the leader of the group.

Matisse was the only member of the Fauvists to adhere to Fauvist principles of pure color throughout his life. From 1917 onwards he spent much of his time on the French Riviera, drawing on the rich colors and bright light of the south for his inspiration. Two operations for intestinal cancer in 1941 left him confined to a wheelchair and he often contrived to work

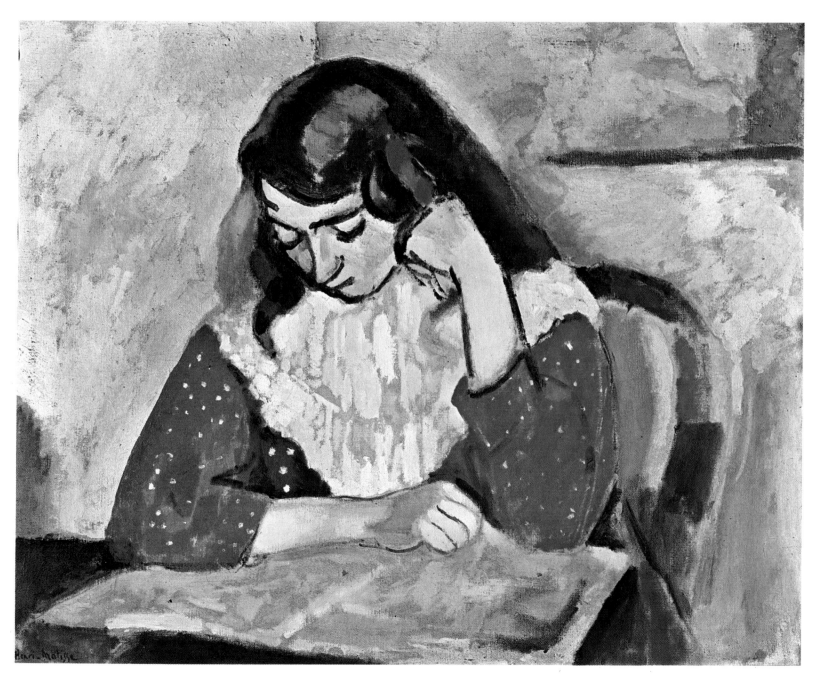

Henri Matisse:*Marguerite Reading,* 1906

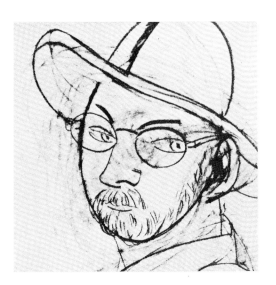

Self Portrait, 1941

from his bed, using a crayon attached to a long pole. Despite this, he created one of his greatest works during this period - *The Chapel of the Rosary at Vence,* which he designed in gratitude to the nuns at the Dominican convent there who had nursed him. He was responsible for every detail, right down to the priests' vestments, and the characteristic glowing colors of the stained glass windows were contrasted with murals of white ceramic tiles bearing black line drawings of remarkable simplicity.

In his final years Matisse invented a technique of using brightly colored paper cut-outs arranged into abstract patterns.

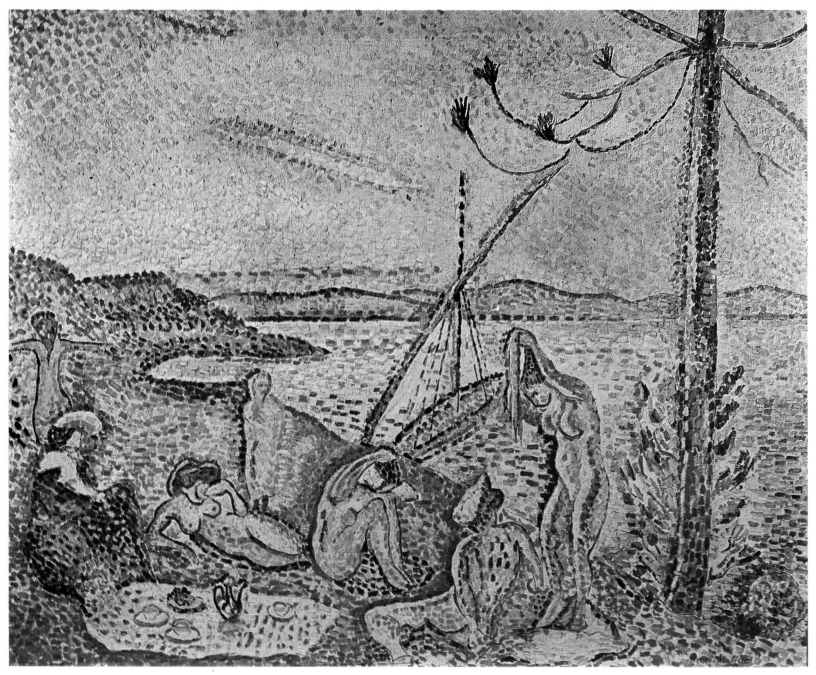

Henri Matisse: *Luxe, calme et volupté,* 1904-1905

Indeed, so brilliant were the colors that his doctor advised him to wear dark glasses. Though he lived through two world wars, he had no interest in expressing any of the violent upheavals of his time in his art; what he dreamt of, he wrote, was an art of balance, purity and serenity devoid of troubling subject matter. Matisse died in 1954, leaving an astonishing body of work behind him: sculptures, ballet sets and costumes, exquisite book illustrations and his joyous paintings.

His work is to be found in most of the major collections of modern art, and he is commemorated at Le Cateau, his birthplace, by a Matisse Museum.

The Fisherman, 1905

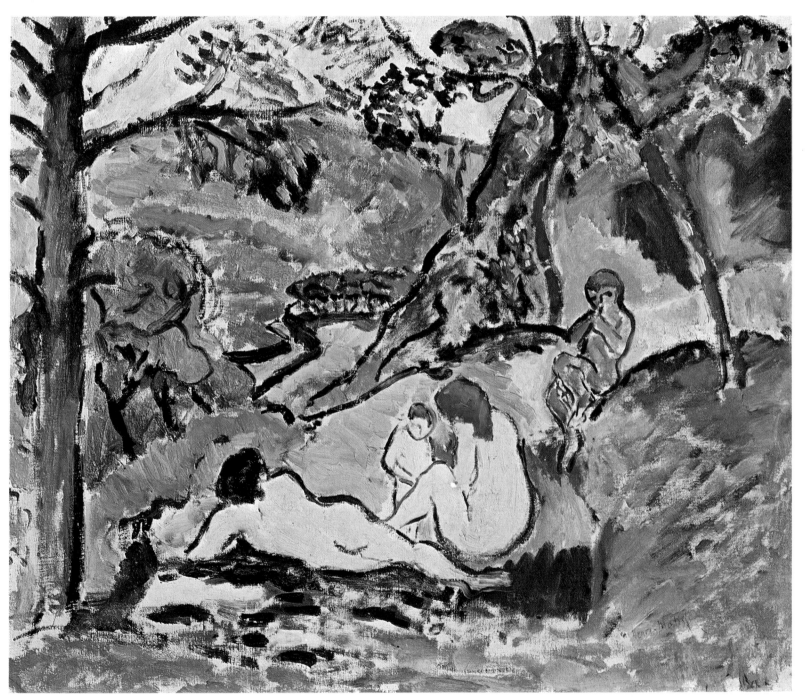

Henri Matisse: *Pastoral*, 1905

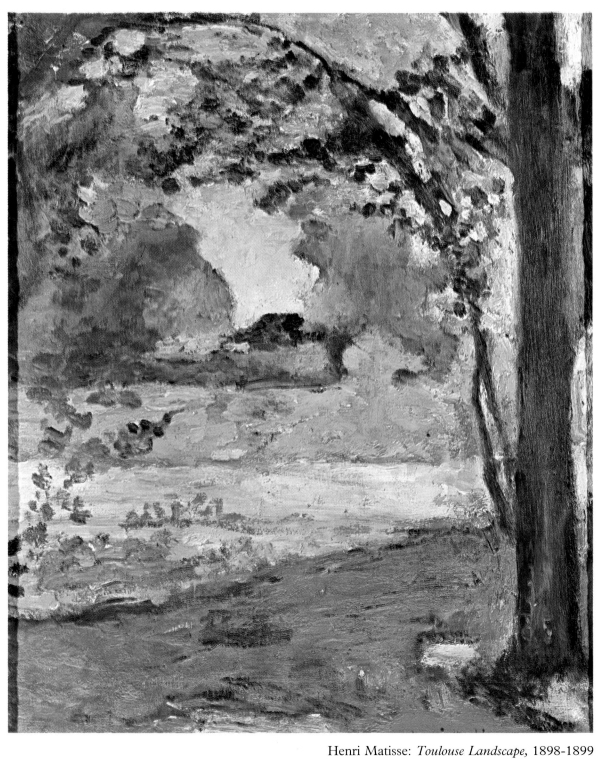

40 Henri Matisse: *Toulouse Landscape,* 1898-1899

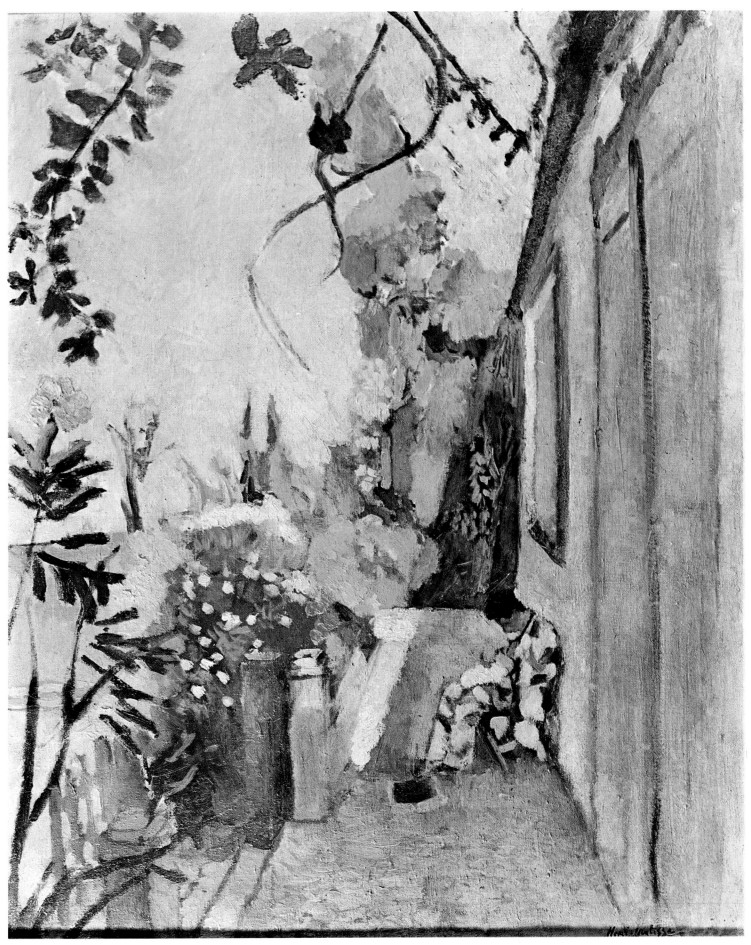

Henri Matisse: *The Terrace of Paul Signac at St Tropez*, 1904

41

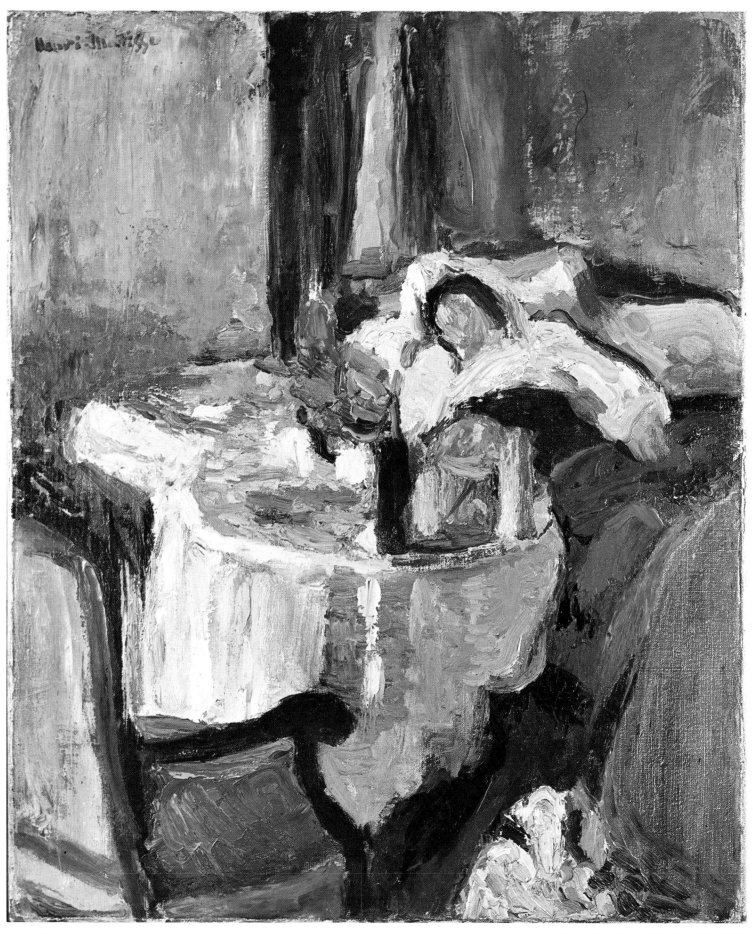

Henri Matisse: *The Invalid*, 1899

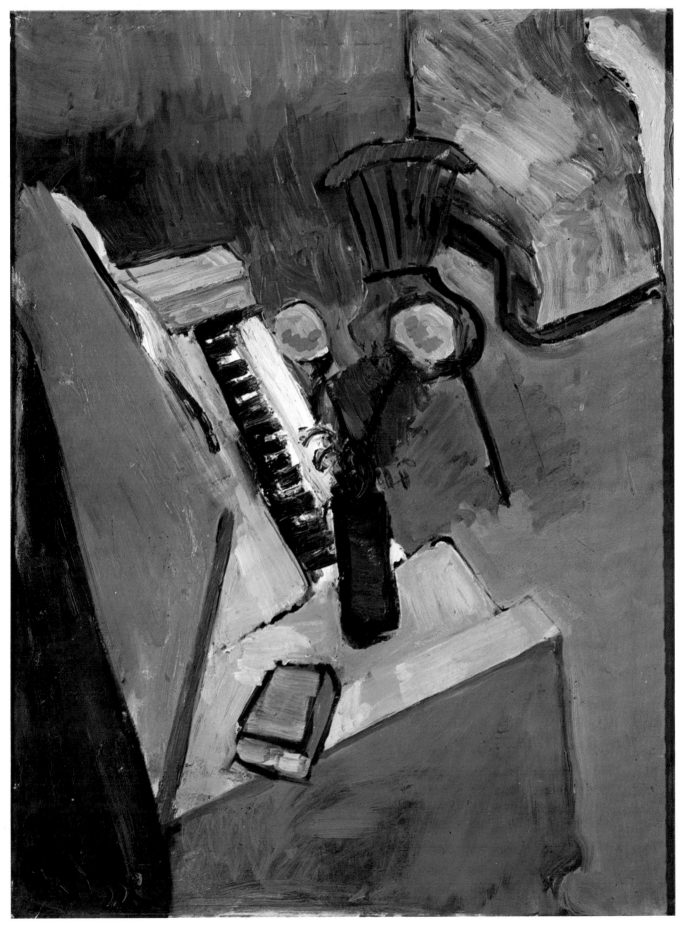

Henri Matisse: *Interior with Harmonium,* 1900

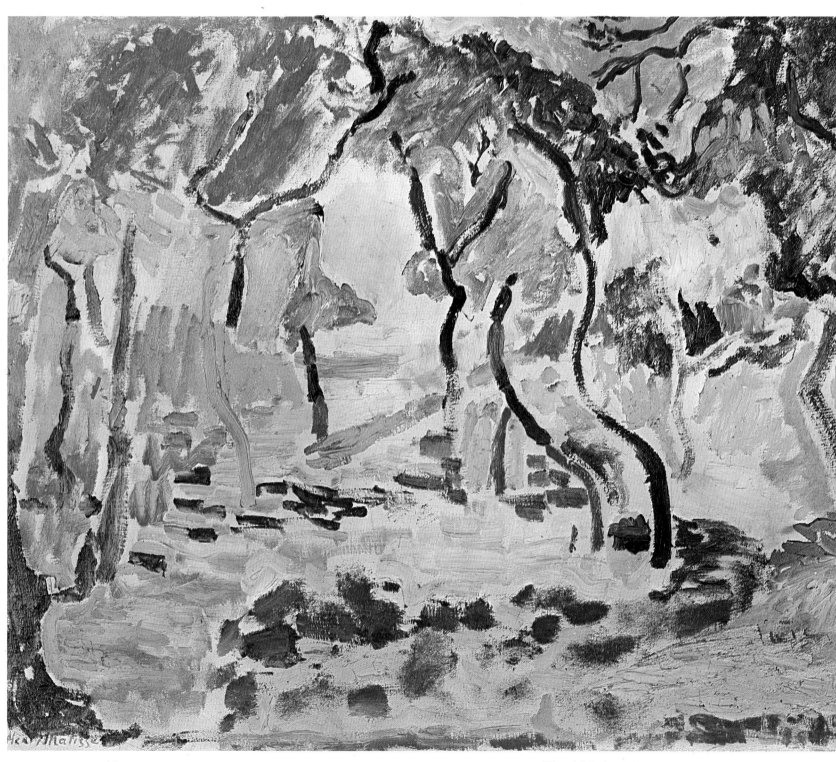

44 Henri Matisse: *Study for 'The Joy of Life'*, 1905

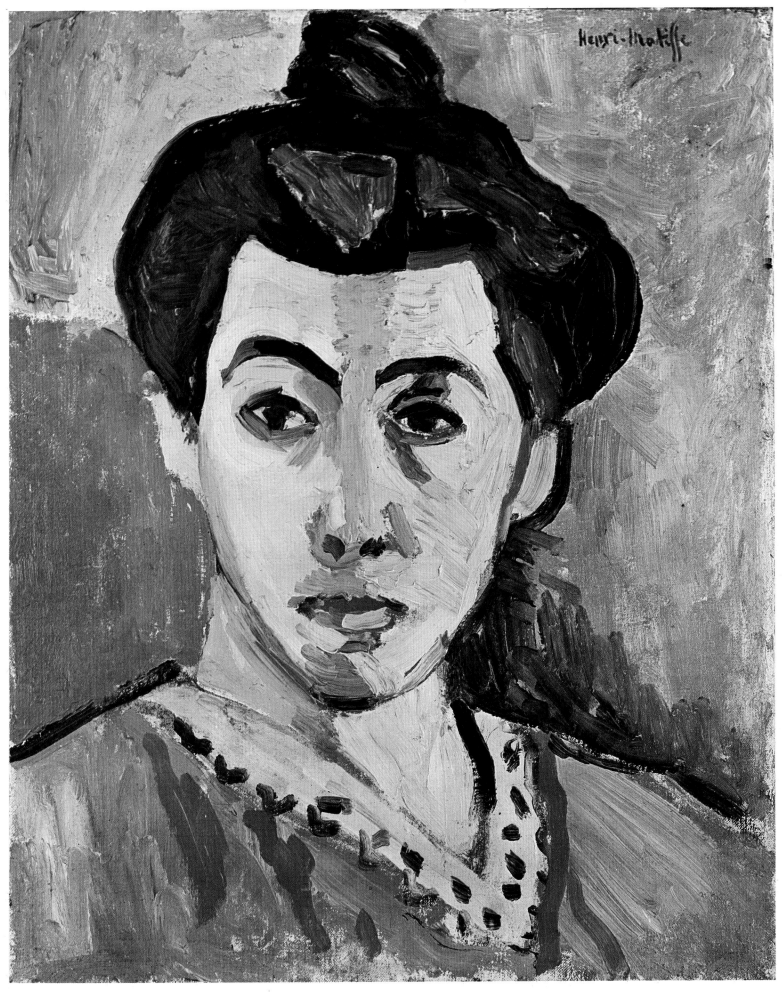

Henri Matisse: *Madame Matisse: 'The Green Line'*, 1905

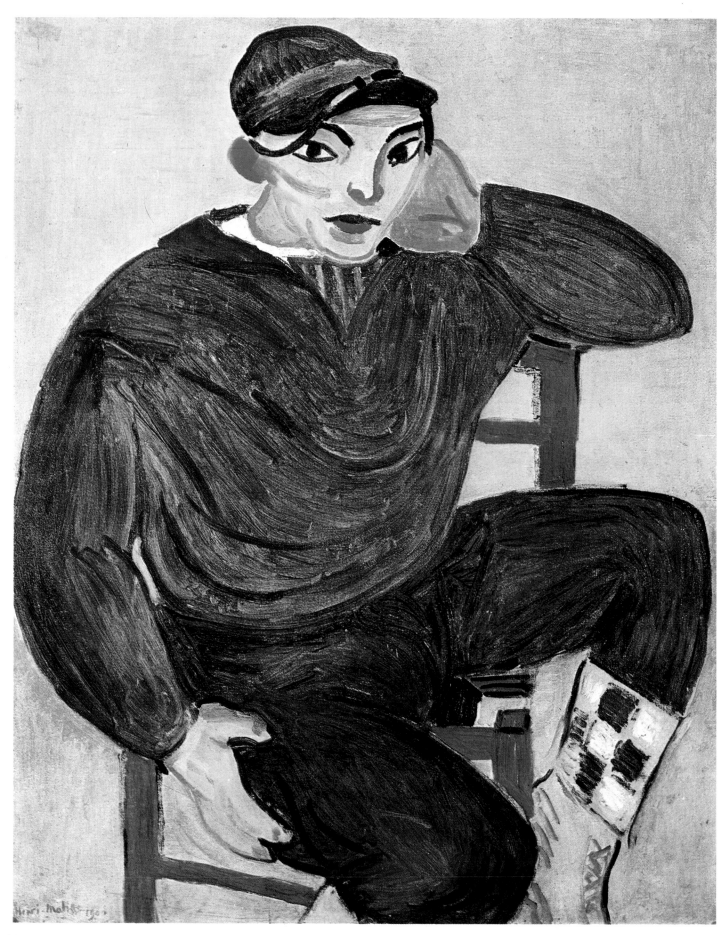

Henri Matisse: *Young Sailor (version II)*, 1906

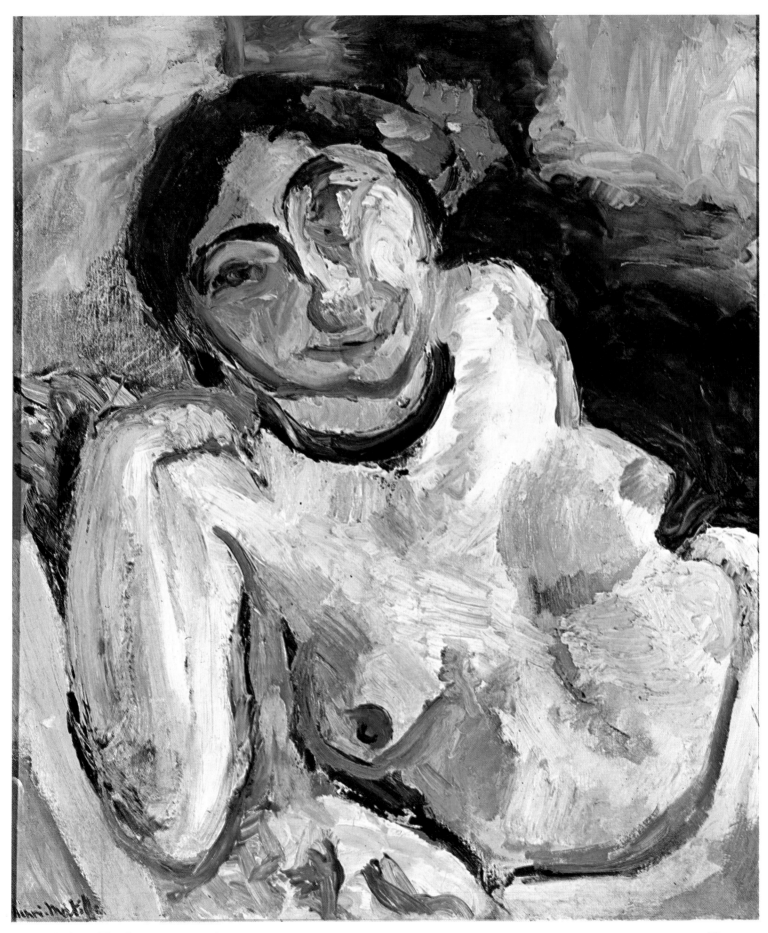

Henri Matisse: *The Gypsy,* 1905-1906

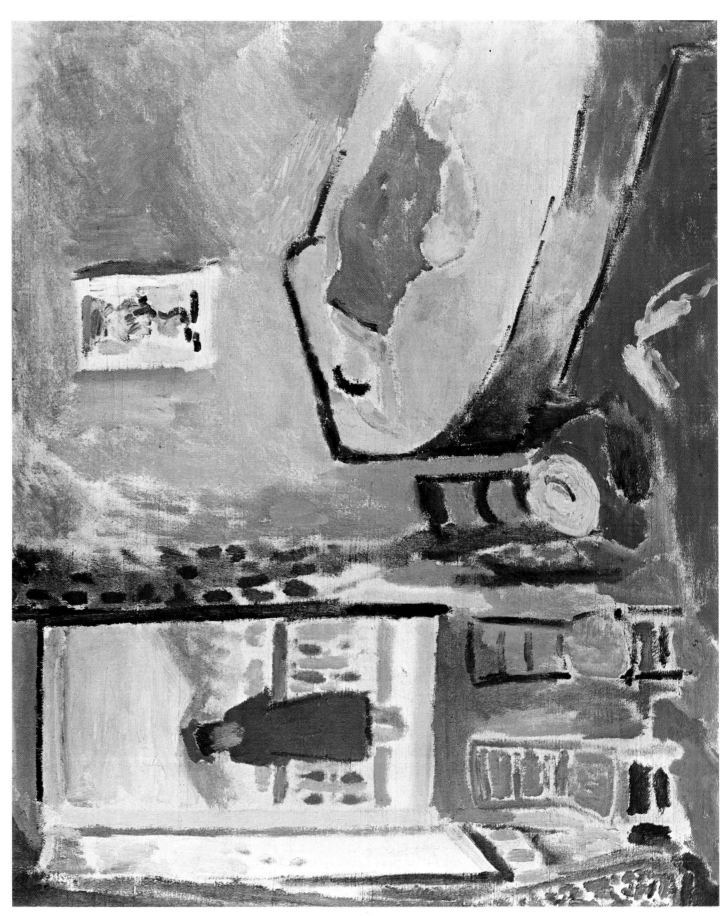

Henri Matisse: *Interior at Collioure,* 1905

Jean Puy Born in Provence in 1876, Jean Puy attended the Ecole des Beaux-Arts in Lyon before moving on to the Academie Julian in Paris. He was much influenced by Matisse and Derain and exhibited with the Fauves from 1901. He found a ready market for his work, which drew mainly on the landscape of Brittany and the female figure. He died in 1960.

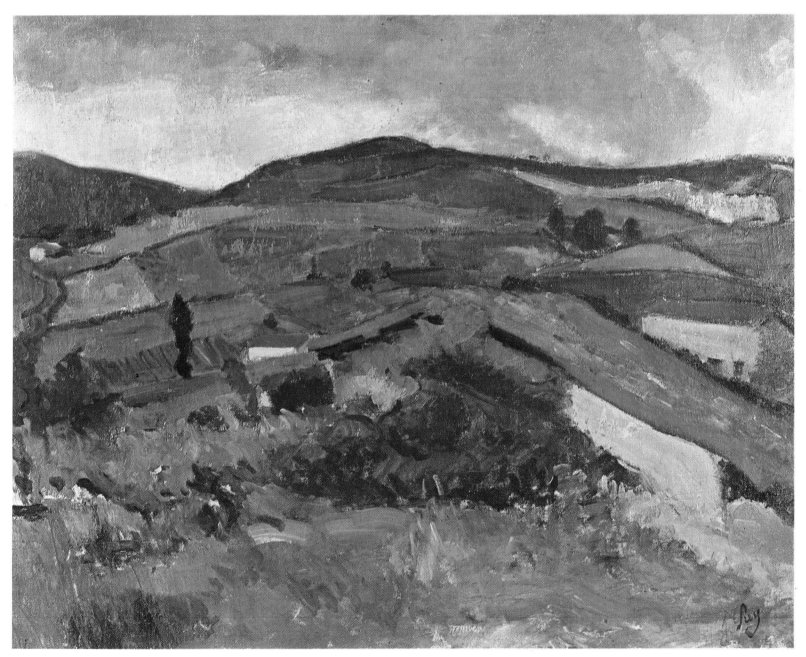

Jean Puy: *Landscape,* 1904

Louis Valtat Valtat was born in Dieppe, Normandy, in 1869. His early paintings were influenced by Bonnard and Vuillard, members of the Nabis group, and by the Pointillists; it was in 1895 that his canvases began to display the brilliant luminosity of color associated with Fauvism. Five of his paintings were exhibited in the 1905 Salon d'Automne. He was struck by blindness in 1948 and died in Paris in 1952.

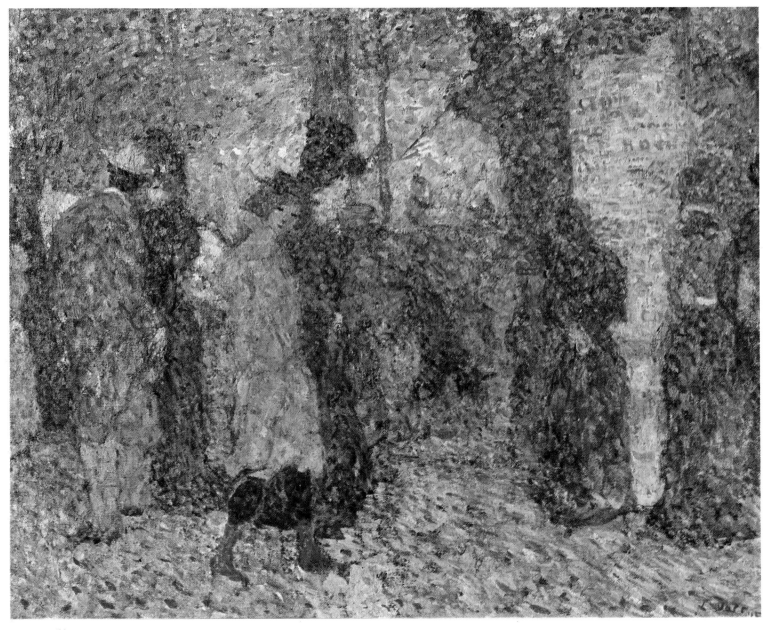

Louis Valtat: *The Madeleine-Bastille Omnibus*, 1895

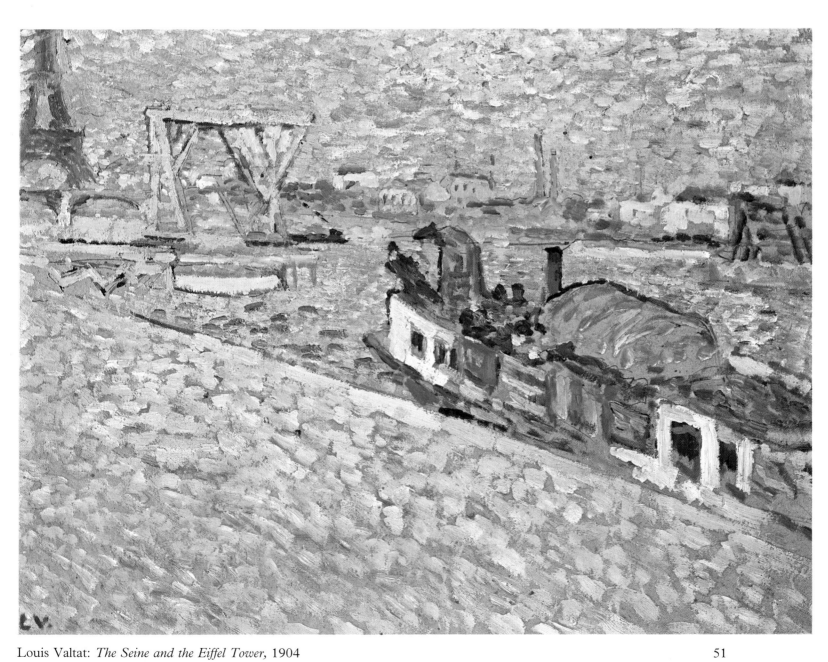

Louis Valtat: *The Seine and the Eiffel Tower*, 1904

Kees van Dongen

Born in the Netherlands in 1877, he took some early art training and worked as a newspaper illustrator in Rotterdam before arriving in Paris at the age of 20 to devote himself to a career in art.

His first year there was a struggle both artistically and economically and he returned home for a period to recoup.

After accumulating some money earned by doing illustrations he made a second attempt at life in Paris in 1900, though this time he made things more difficult for himself financially by getting married and starting a family. He personified the image of a bohemian artist, working as a house painter, cafe artist and illustrator of satirical newspapers, making ends meet as best as he could.

In 1904 the dealer Ambroise Vollard offered him a one-man show, which was well received by some critics, and he also exhibited with the Fauves at the Salon des Indépendents. Although he continued to exhibit with the Fauves until 1907 his style displayed elements of Expressionism and in 1908 he was invited to join the German Expressionist group Die Brucke (the Bridge). Van Dongen's art became immensely popular and he embarked on a luxurious life in exclusive Parisian circles. After World War I he concentrated on paintings of cafe society and fashionable, frivolous women, and his art became rather repetitive and banal. Though he lived until the age of 91, dying at his home on the Cote d'Azur in 1968, his best work was all done before 1920.

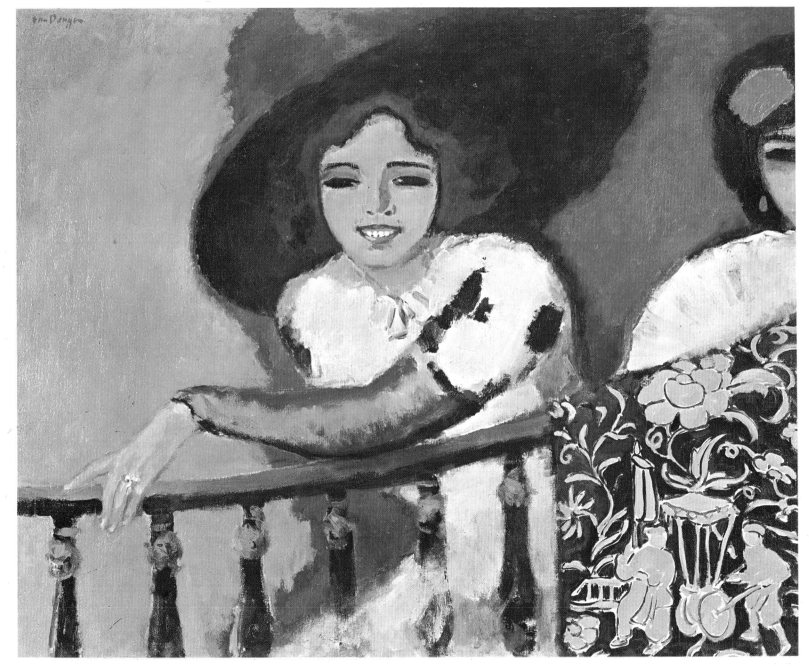

Kees van Dongen: *Woman at the Balustrade,* 1907–1910

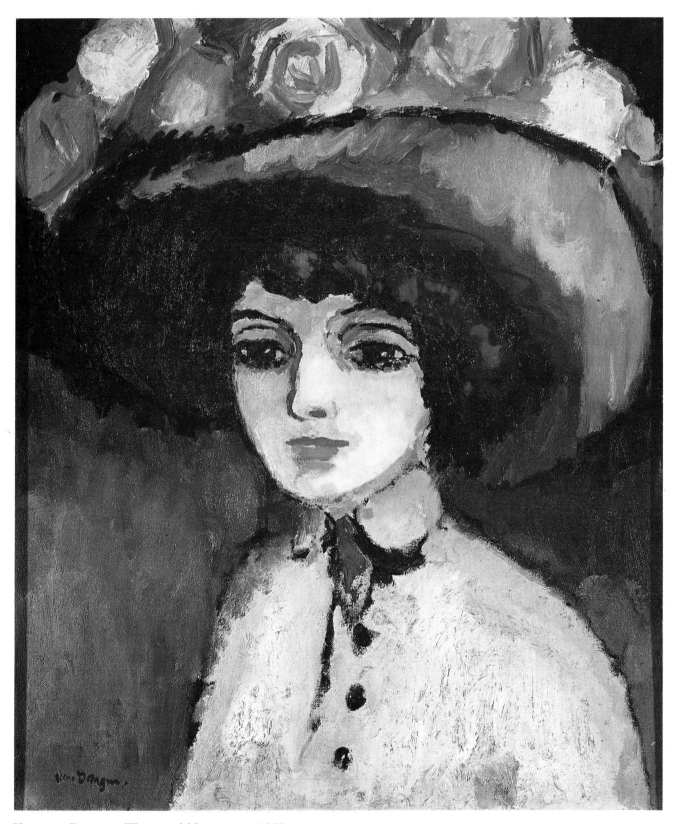

Kees van Dongen: *Woman of Montmartre*, 1930

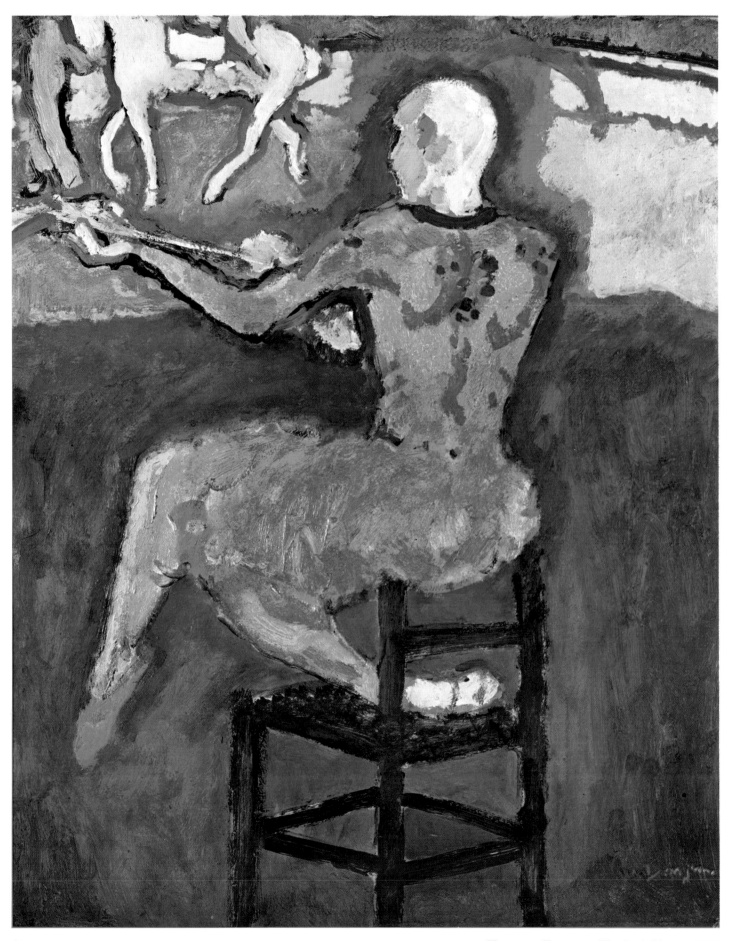

Kees van Dongen: *The Red Clown*, 1905

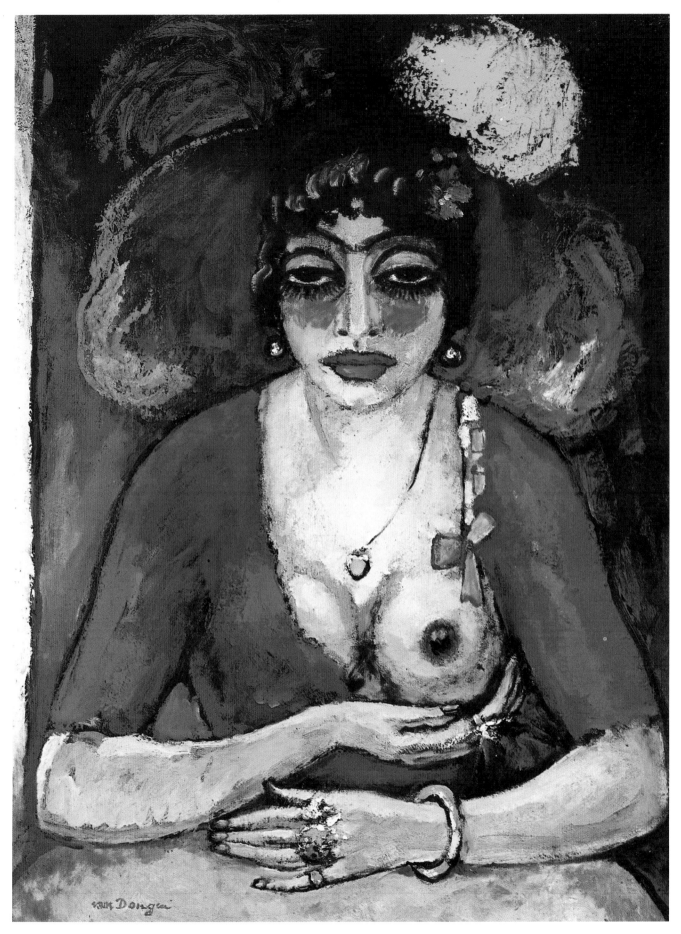

Kees van Dongen: *Femme Fatale,* 1905

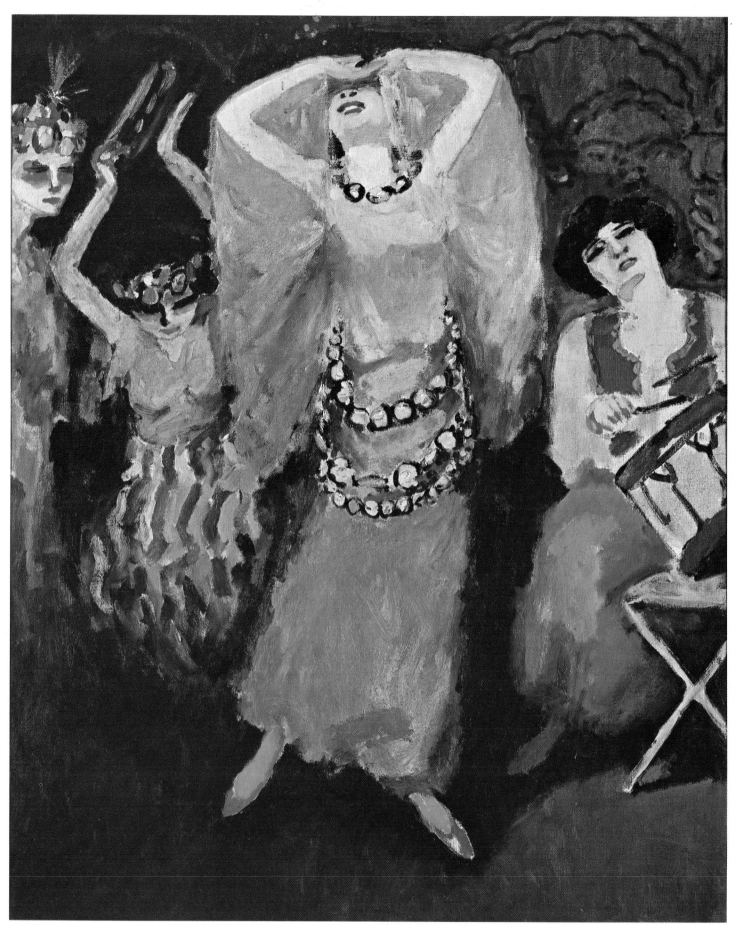

Kees van Dongen: *Fatima and Her Troupe*, 1906

Maurice Vlaminck

Vlaminck's explosive talents were not confined to painting, for he also managed to earn a living as a musician, novelist, actor and even professional bicycle racer.

Born in Paris in 1876, he moved to Chatou at the age of 16 and by 18 was already married with a daughter. His meeting with Derain, on a train near Chatou, was to prove a turning point in his restive career and from then on his energies were concentrated mainly upon painting.

He rejected all forms of academic training, boasting that he had never even entered the Louvre. An exhibition of Van Gogh's work in 1901 made a deep impression upon him that was manifested in his painting, in which blazing colors were applied in thick daubs. His landscapes of 1903 and 1904 were the first paintings in truly Fauvist style and by 1906 he had reached a peak in his progression towards mastery of pure color.

By 1908, however, he was turning towards landscapes in greys, white and blues and his style moved closer to that of Cézanne.

By 1915 he had evolved a personal style that was essentially French Expressionist, using darker colors than in his Fauve period. After World War I he moved to the countryside, where he lived in some isolation until his death in 1958.

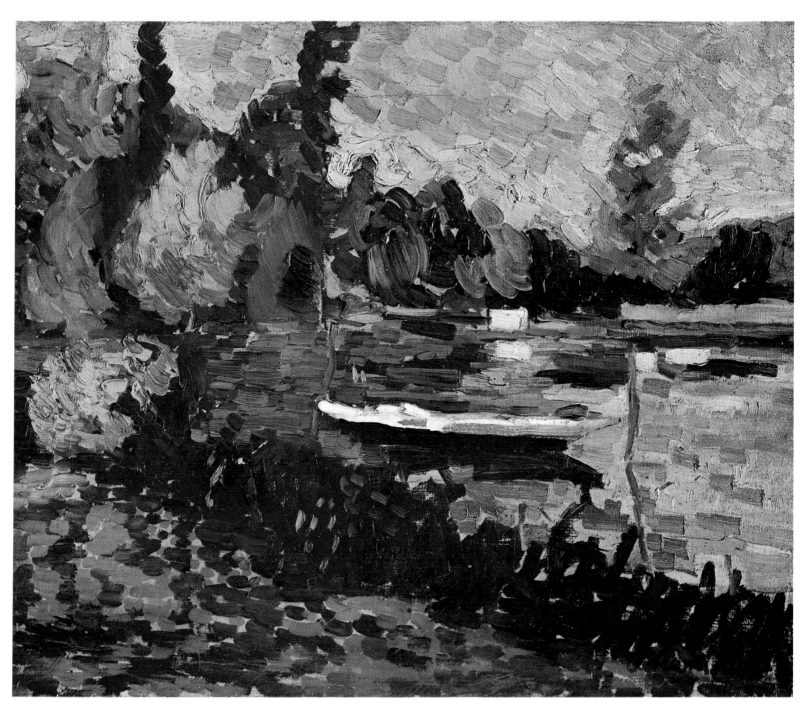

Maurice Vlaminck: *The Pond at St Cucufa,* 1903

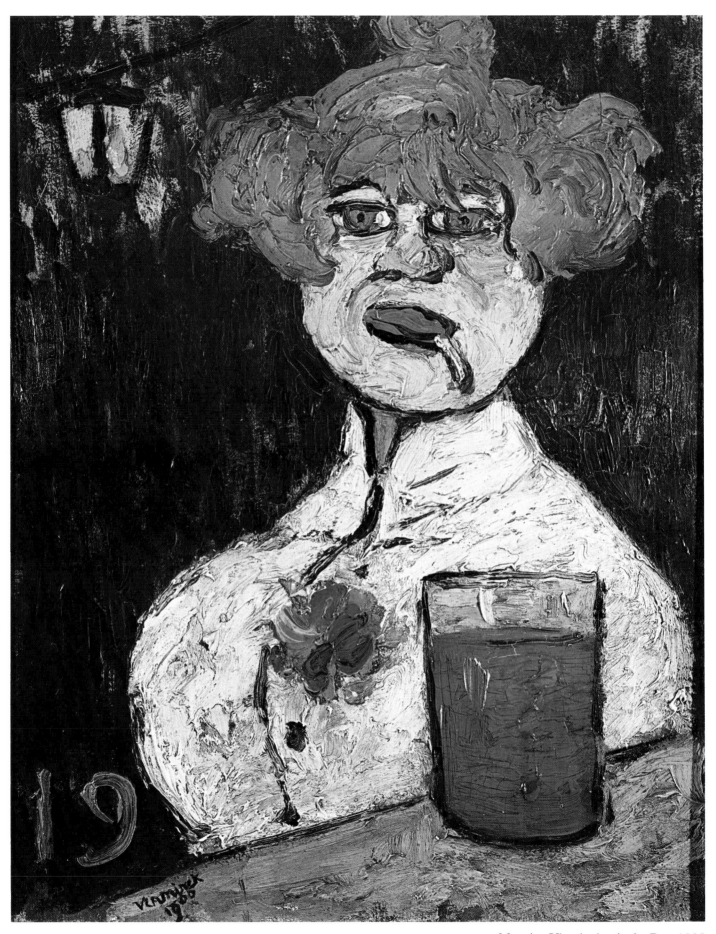

Maurice Vlaminck: *At the Bar*, 1900

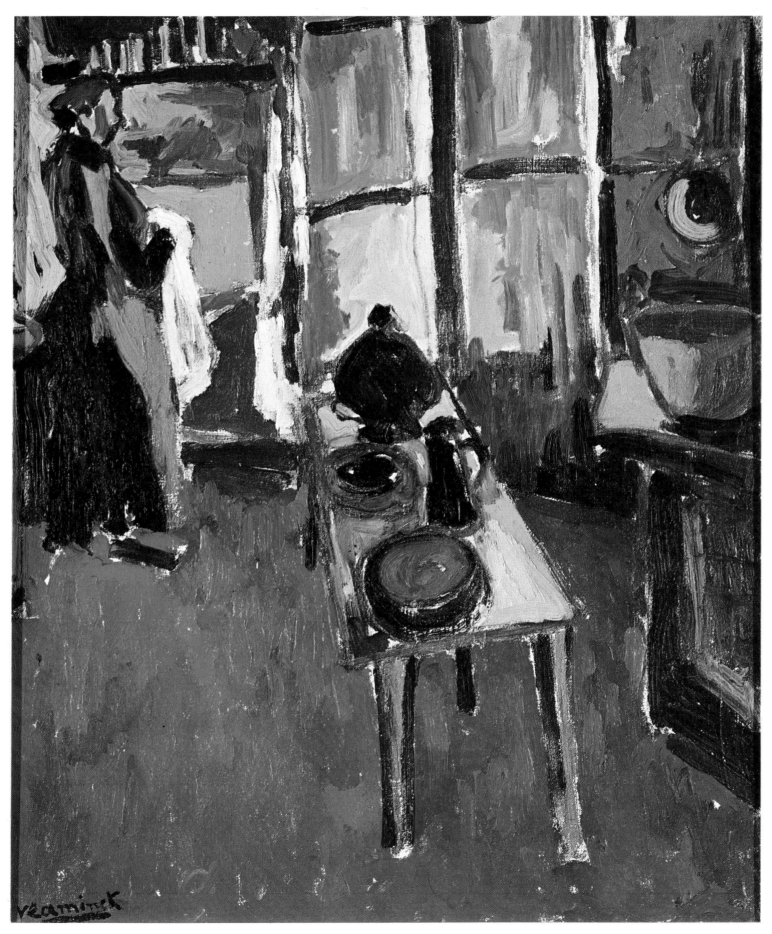

Maurice Vlaminck: *Kitchen Interior,* 1904

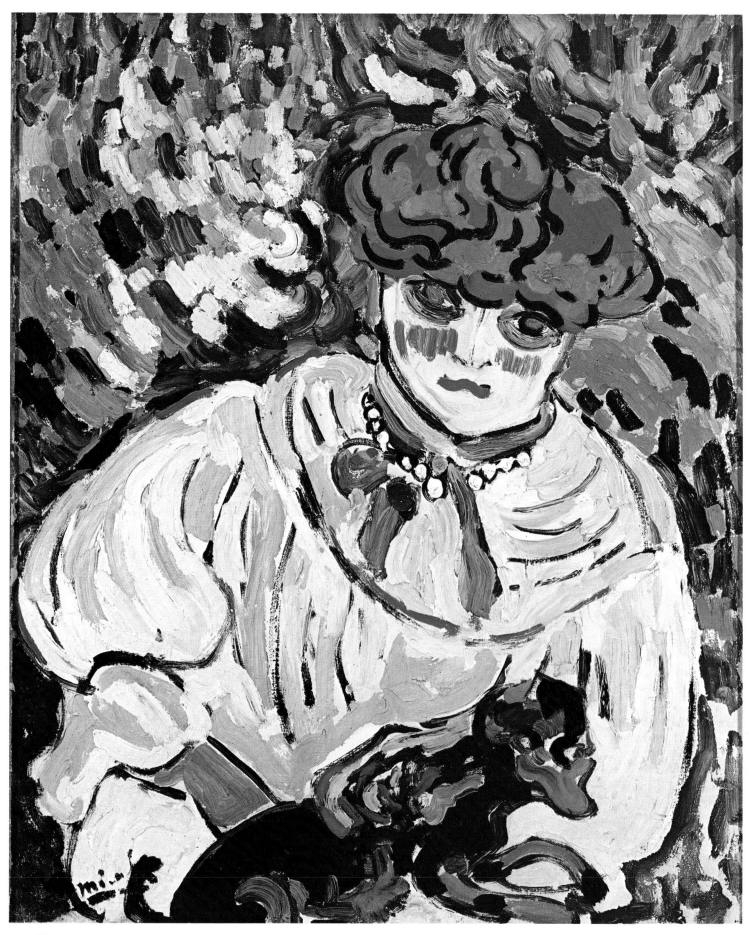

Maurice Vlaminck: *Portrait of a Woman*, 1906

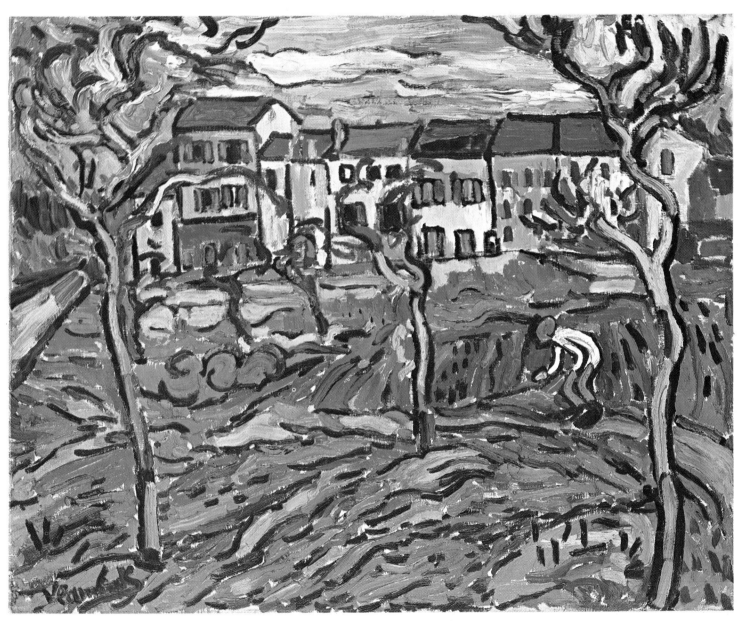

Maurice Vlaminck: *Houses at Chatou*, 1903

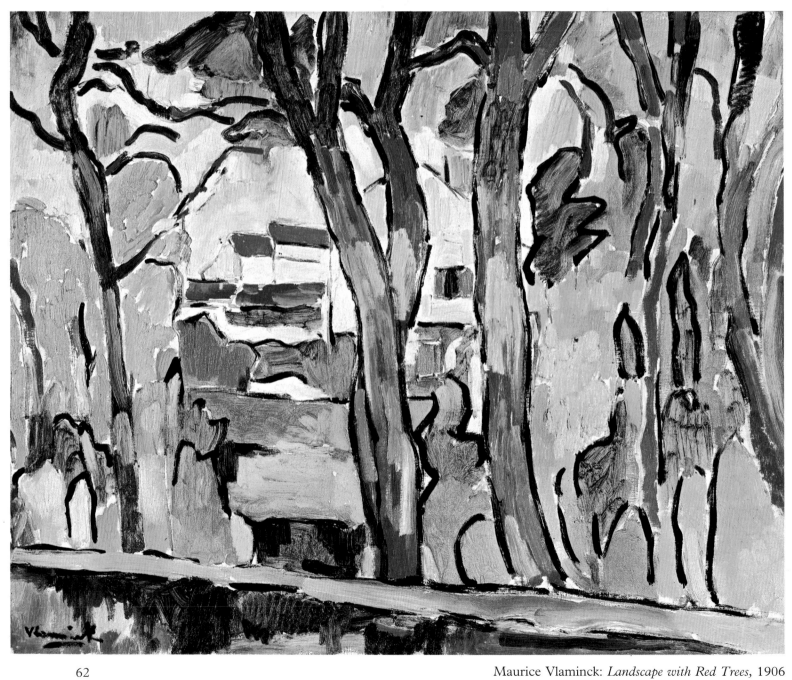

Maurice Vlaminck: *Landscape with Red Trees*, 1906

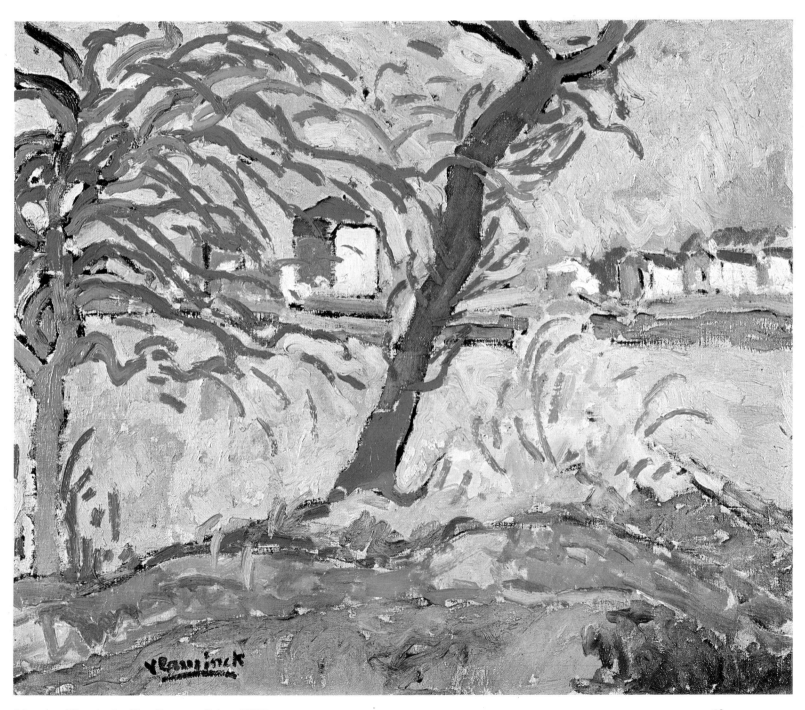

Maurice Vlaminck: *Carrières-sur-Seine*, 1906

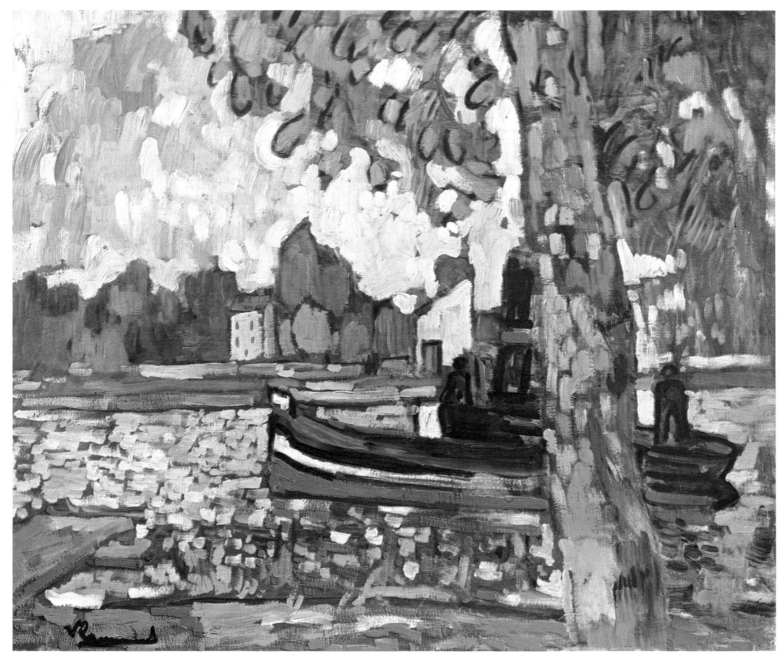

Maurice Vlaminck: *The Tugboat*, 1905

The end of Fauvism The year after the Fauves had gained their name they exhibited again at the Salon d'Automne. However, the decline of Fauvism was already on the horizon as its members were attracted by new directions in art, notably by a revival of interest in Cézanne as a result of a large retrospective exhibition of his work following his death in 1906. Together with African sculpture, the disciplined structures of his later paintings were to inspire Cubism, which was originated by Picasso and Braque in 1906-7 and became a major turning point in European art from which numerous other movements were to spring. Compared to the impact of Cubism on 20th-century aesthetic attitudes Fauvism might seem like a fleeting episode; yet its brief lifespan belies its importance, for its definitive breaking of the bonds of traditionalism gave 20th-century artists the freedom to find new forms of expression. Its echo can be found in many movements in modern art which experiment with the use of color, and it was to be a major influence on German Expressionism.